IMAGES
of America

TUSCARORA NATION

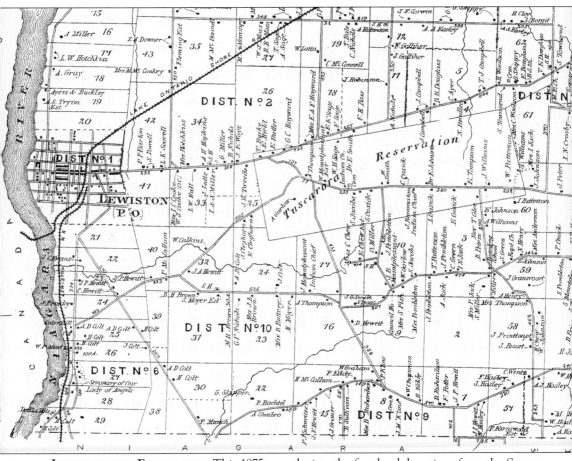

LIVING ON THE ESCARPMENT. This 1875 map depicts the first land donations from the Seneca Nation and Robert Morris to the Tuscarora people in 1797. The area measures one square mile by three square miles and is located atop the Niagara Escarpment. It was added to by a Holland Land Company purchase in 1804. The final number of acres for the Tuscarora Nation was 6,249 until the taking of land by Robert Moses and the New York State Power Authority in 1958. (Courtesy Tuscarora Environment Office.)

On the cover: **TUSCARORA MARRIAGE CEREMONY.** In 1934, the "Four-Nation Celebration" was held in Niagara Falls. As part of the celebration, a traditional marriage ceremony was conducted along the Niagara River by Tuscarora chief George Rickard. The marriage of Clifford Printup and Vivian Rickard was viewed by Tuscaroras, tourists, and celebration attendees. (Courtesy Niagara Falls Public Library.)

IMAGES
of America

TUSCARORA NATION

Bryan Printup and Neil Patterson Jr.

ARCADIA
PUBLISHING

Published by Arcadia Publishing
Charleston SC, Chicago IL, Portsmouth NH, San Francisco CA

Printed in the United States of America

Library of Congress Catalog Card Number: 2006934561

For all general information contact Arcadia Publishing at:
Telephone 843-853-2070
Fax 843-853-0044
E-mail sales@arcadiapublishing.com
For customer service and orders:
Toll-Free 1-888-313-2665

Visit us on the Internet at www.arcadiapublishing.com

*To the elders and community members of the Tuscarora Nation,
nyà:wę for your knowledge and inspiration, but more importantly,
to our faithful families and friends for their support.*

CONTENTS

ACKNOWLEDGMENTS

The completion of this book was made possible by a dedicated few who collaborated with their exploration, writing, and passion for the history of Tuscarora. Our heartfelt gratitude goes to Chief Kenneth Patterson, Richard Hill Sr., Joanne Weinholtz, Vincent Schiffert, and the Tuscarora Environment Program (TEP) staff for their many hours of dedication to this project.

There are several Tuscarora families to whom we are very grateful for their knowledge and photograph contributions. Many nyà:węs to James and Wendy Bissell, Sarah Brascoupe, Elden Fischer, Elden Jr. and Patricia Fischer, Suzanne Goater, Leona Gonzalez, Eugene and Elva Greene, Richard Hill Sr., Deborah Holler, Patty Jacobs, Martin Johnson, Jerry and Lorraine Jonathan, Karen Kneeppel, Audrey Larocca, Michelle Lewis, Imogene Mt. Pleasant, Stuart Patterson, Susan Patterson and family, Ann Printup, Claudia Reed, Fillmore and Dorene Rickard, James and Dee Rickard, Patricia Wergerski, Theodore Williams and family, and Theresa Wilson.

We also wish to thank the numerous institutions who opened their doors and shared their wealth of information and photographs with us. Thanks go to the Niagara Falls Public Library Local History Department, Orrin Dunlop Collection, Lewiston Historical Society, Tuscarora Indian School, Autry National Center's Southwest Museum of the American Indian, National Anthropological Archives, Buffalo Courier Express Collection of Buffalo State College Archives, Lewiston Historical Museum, Porter Historical Museum, and the National Philosophical Society.

A portion of the proceeds from this publication will go towards the collecting and archiving of oral history and photographic documents about Tuscarora. These efforts will be administered by the TEP and the Haudenosaunee Environmental Task Force.

Suzanne Simon Dietz, author of Lewiston and Porter, provided the initial push for our publication dedicated to the history of Tuscarora. Her support and guidance are greatly appreciated by both of us and we cannot thank her enough for the words of encouragement she gave us through this entire process. We thank you very much Sue, for everything.

Finally, we wish to acknowledge the beautiful process of oral history passed down from generation to generation. As the faces of the unborn come up from the ground, we give thanks and show gratitude to our parents, grandparents, and the many elders who cherish the history of our people and keep it alive.

INTRODUCTION

The story of Tuscarora has received less attention than many other natives of North America, yet their story is probably one of the most amazing tales of survival found in the western hemisphere. Tuscarora has the unique distinction of being the first Native American nation dispossessed of its land during the European settlement of North America. Their survival is a testament to the adaptability of Tuscarora culture and to the compassion found among the other Five Nations of the Haudenosaunee, or Iroquois Confederacy, collectively the Seneca, Cayuga, Onondaga, Oneida, and Mohawk. Together they are called Iroquois, but they prefer to call themselves *Haudenosaunee*, meaning "People of the Extended House," a metaphor for the nations living together in peace under one common law.

While the Five Nations were building an empire and developing a reputation as the most powerful force east of the Mississippi River, the Tuscaroras, the largest and strongest group in their area, were living between the mountains and the waters of the ocean in what is now called North Carolina. Tuscaroras, who called themselves *Skarù:rę*, meaning "people of the hemp" or "those who wear shirts," speak an Iroquoian stock language like their brothers to the north. They were considered the southern extent of the Iroquois empire, connected by north–south trails used extensively for trade. Their life consisted of farming and fishing the bountiful Atlantic coast. Things would change when the white settlers began to encroach on their villages in the 1700s.

In 1711, Tuscaroras captured John Lawson and put him to death because of his hostile dealings in taking Tuscarora lands for white settlement. After these early events of the Tuscarora Wars in the Carolinas, the Tuscaroras were attacked in 1712 by Colonel Barnwell of South Carolina.

A peace was negotiated, but many Tuscaroras were put into slavery, which led to a second war breaking out in 1713. Aggressors took forts at Neoheroka and Catechna in North Carolina. It is estimated that 500 Tuscaroras were killed and another 300 wounded. This loss was so devastating to the remaining Tuscarora that they decided to abandon their homes and head north.

In 1714, chiefs of the Five Nations delivered a wampum belt to New York governor Hunter, with the message that the Tuscarora "are come to shelter themselves among the Five Nations: they were of us and went from us long ago, and now are returned and promise to live peaceably among us. And since there is peace now everywhere, we have received them."

In 1722, the Haudenosaunee held a Grand Council, at which the Tuscarora Nation made an application, through their brothers the Oneida, to be admitted into the Confederacy. The application was granted, and a wampum belt was commissioned. They were granted land in Oneida territory, in New York. Some Tuscaroras remained in Maryland and Pennsylvania

settlements. From 1714 until 1770, many small groups of Tuscaroras made their way north from the Carolinas, hearing of their brethren finally resting and making a home.

Shortly after finding a home among the Oneidas, Tuscarora again found itself scattered and homeless due to another war, the American Revolution.

Most of the Six Nations tried to remain neutral, but the Tuscarora and the Oneidas eventually backed the colonists while other Haudenosaunee nations sided with the British. Gen. George Washington ordered the army to indiscriminately destroy Iroquois settlements throughout the Finger Lakes and the Genesee Valley. Tuscaroras were driven out of their villages in Oneida country, as they were burned and razed.

Although still scattered and in hiding, a large group of Tuscarora settled at Johnson's Landing Place, or Oyonwayea, located near Fort Niagara, about four miles east of the mouth of the Niagara River. Many of them were also utilizing a popular campsite near an old Native American village known as Keinuka or Gaustrauyea on the Niagara Escarpment. Tuscaroras sought permanent ownership of this land during the Treaty of Big Tree in 1797. The Senecas granted one square mile of land to the Tuscaroras. Upon hearing of the Seneca donation, Robert Morris doubled the Seneca grant and added another two square miles before the treaty was ratified, establishing a permanent reservation of three square miles.

From monies secured for leasing Tuscarora lands in North Carolina, Secretary of War Henry Dearborne, under the authority of Congress, purchased 4,329 acres of land in upstate New York for the Tuscarora from the Holland Land Company. These lands joined the three square miles they had been occupying along the escarpment. In 1803, Chief Sekwari:θre led the remaining Tuscarora north from North Carolina to a permanent home.

Life was altered when the British invaded Tuscarora during the War of 1812. The entire Tuscarora community, including the homes, barns, school, church, and livestock, was burned by the British. The Tuscarora, Seneca, Onondaga, and Oneida came to the aid of the fledgling United States and helped to turn back the invading British forces. When the British burned down property at Tuscarora, Tuscaroras rallied and turned the British back.

The Tuscarora used ancient patterns of agriculture to rise from the ashes of the War of 1812. They produced more crops as a source of cash and then built bigger and better homes to live in, and by the 1820s the community began to prosper.

In 1830, the Tuscarora Temperance Society was formed. Excessive drinking of alcohol had become a major problem among the Haudenosaunee since the late 1600s. At the beginning of the 19th century, a Seneca had a series of visions that preached against the use of alcohol, gambling, social dancing, witchcraft, and abortion. While we do not know whether this man, Handsome Lake, ever delivered his message at Tuscarora, an anti-alcohol movement did sweep through the Six Nations.

The 1845 United States census conducted at Tuscarora provides some insight into what life was like. The family names on that census are still found on reservation mailboxes today—Jacobs, Mt. Pleasant, Chew, Hewitt, Johnson, Printup, Pembleton, Green, Gansworth, Patterson, Smith, Rickard, Cusick, Fish, and Henry. These families make up the heart of the Tuscarora Nation today. In 1845, there were 322 people reported living on the reservation.

In 1887, the United States Congress passed the Dawes Act to allot reservation lands into individual plots and to replace traditional Native American governments with a reorganized constitutional government. Although the Dawes Act did not affect the Tuscarora (because their lands were not considered to be held in trust by the United States), the New York legislature established a commission to investigate whether the Dawes Act could be forced on Native Americans. The Whipple Commission was charged with proving that Native American governments were antiquated and dysfunctional systems that could be rectified by making the Native Americans wards of the state.

In 1888–1889, the Whipple Committee Report was produced to advocate changes for the Iroquois away from the "old tribal" system and towards a democratic election. The commission also recommended that Haudenosaunee lands be divided up into individual ownership. This

would bring an end to the reservation because the land was held in trust by the nation. At Tuscarora these attempts to abolish traditional government failed.

A few years after the Whipple Committee Report was issued, an extra census bulletin of the 1890 census called *The Six Nations of New York*, set out to substantiate the claims of the Whipple Committee. The plan backfired. Not only did *The Six Nations of New York* demonstrate why Tuscarora leaders believed their sovereignty was intact, it presented evidence demonstrating an ability to balance Tuscarora traditionalism with contemporary changes happening around them. Tuscarora families operated family farms at the same time that much of the reservation land was leased to outside farmers. In 1824, a newspaper account noted that "as a nation, or tribe, they are rich, and many of them, as individuals." Tuscaroras even became the principal money lender in Niagara County. This was the result of annual lease payments from lands in North Carolina, successful farming, and what one missionary called "correct ideas of property."

The Six Nations of New York reported that "the Tuscarora near Niagara are especially skillful in beadwork, but every reservation has its experts as well as its novices at this calling." Tuscarora beadwork was very popular as souvenirs of a visit to the mighty Niagara Falls. Since the 1700s, beadwork has become a very important expression of identity at Tuscarora.

Tuscarora was enjoying what is often called the golden age of prosperity and wealth until the middle of the 20th century, when New York State disrupted the peace and brought another traumatic removal of Tuscarora people from their land.

In 1950, the United States Congress transferred civil jurisdiction over Native Americans to New York State, despite the objections of the Haudenosaunee. Federal treaties specifically mention how the two nations are to interact. The Tuscarora viewed such a change as a violation of those treaties, therefore insisting that the treaty obligations be maintained. One of those obligations is the distribution of annuity cloth to Haudenosaunee members. In the 18th century, treaty cloth, made of white muslin, was considered valuable. Today it is considered even more valuable, not as cloth, but as a symbol that the treaty continues to be recognized. In 1955, the federal government offered the Tuscarora a lump sum payment of $150,000 in lieu of the cloth payment, but the council turned it down, hoping that as long as the cloth was given, the rest of the Canandaigua Treaty of 1794 would be recognized.

The state declared in 1954 that it would not recognize the hereditary chiefs as the spokesmen for reservation Native Americans, and would only deal with elected councils. State police began to arrest Tuscaroras for violating New York State traffic and hunting laws on the reservation. Despite all attempts to remove the chiefs, New York State failed, and today the Council of Chiefs is still recognized as the only government of the Tuscaroras.

The most dramatic threat to the Tuscarora Nation came in the form of a battle with the New York State Power Authority. They wanted to build a reservoir for the hydroelectric plant near the mighty Niagara Falls, and targeted some of the Tuscarora lands to do so. After a long legal battle, the Tuscarora lost their case. The Supreme Court decided the lands were not a reservation according to federal definition, a decision never more wrong in the eyes of Tuscarora people. The Tuscarora lost 557 acres of land, 29 households were relocated, and an internal strife emerged that is still festering on the reservation today.

Today Tuscarora is the smallest of the Six Nations in terms of both population and territory. There are about 1,200 people living at Tuscarora, with a small mixture of other Haudenosaunee living alongside Tuscaroras. There are no police, no jails, no Bureau of Indian Affairs, no Housing and Urban Development homes, no taxes, and no imposed bureaucracy. What there is though, is a timeless government still in operation, a committee to our land, a respect for civility and law, a tradition of sharing and giving back, and a sense of stewardship for our land.

Although the majority of the residents are either Baptist or Catholic, there is a cultural revitalization taking place. There are still patterns of traditional culture at work, such as the Nyú:ya Festival. The festival includes going home to home on New Year's morning to receive gifts of food. Visitors yell "Nyú:ya" at the door, and friends and relatives pass out cookies, cakes, pie, or fruit. It is thought that the Tuscarora may have learned this tradition from the German settlers

in Pennsylvania. Whatever its origins, it has spread to other Haudenosaunee communities as well. The hunt is held prior to that day as a contest between the "old-men," those who have fathered a child, and the "young-men," those who have not. A noonday feast is offered for the entire community to enjoy.

Modern culture still consists of traditional practices handed down from the ancestors: farming the Three Sisters—corn, beans, and squash; growing native tobacco for traditional rites; tapping maple trees for syrup; and hunting still take place. Lacrosse, emerging from the time of Creation and a favorite game of the Creator, is played today by the Tuscarora, who excel at the game. Beadwork has become a mainstay of Tuscarora artistic expression.

The children at the Tuscarora Indian School use the traditional expression of gratitude called the Ganonyok (Thanksgiving Address) to begin and end each week. They have learned to acknowledge the earth, the plants, the animals, the birds, and the forces of nature in the Tuscarora language.

Today the Tuscarora Nation is still organized around several extended families based on a matrilineal society. Families are grouped into clans named after animals—Turtle, Bear, Wolf, Beaver, Snipe, Eel, and Deer. Each clan is headed by a clanmother, and her job is to select their male leaders of the clan, called chiefs. Tuscarora is one of very few native communities in the United States that still operates under a traditional form of government.

There is an old belief that as long as two people gather for the rituals, the Haudenosaunee way of life will continue. The future of the Tuscarora Nation has always been at risk because of the small numbers of people and divisions over the economy and governance. Another belief urges one to think of the "seventh generation to come," when deliberating about what is best for the people. The Tuscarora have to think about how today's decisions will effect the unborn generations. It is this kind of thinking, combined with a consensus of the clans and the actions of each individual to keep the traditions alive, that will assure the continuing survival of the Skarù:rę.

One

SKARÙ:RĘ BEGINNINGS

FORMER MT. PLEASANT HOMESTEAD. The farm records of Niagara County list the Mt. Pleasant farm "one of the fine farms of Lewiston, it's noted feature doubtless being it's fruit orchards, which contained 13 acres of apples: Greenings, Baldwins, and Kings; 13 acres of pears: Bartletts and Keefers; and 700 cherry trees: Richmonds, and Mount Morencis." The Mt. Pleasant farm was located on Moyer Road, between Gill and Fish Creeks, and later became the Patterson farm. (Courtesy Chief Kenneth Patterson.)

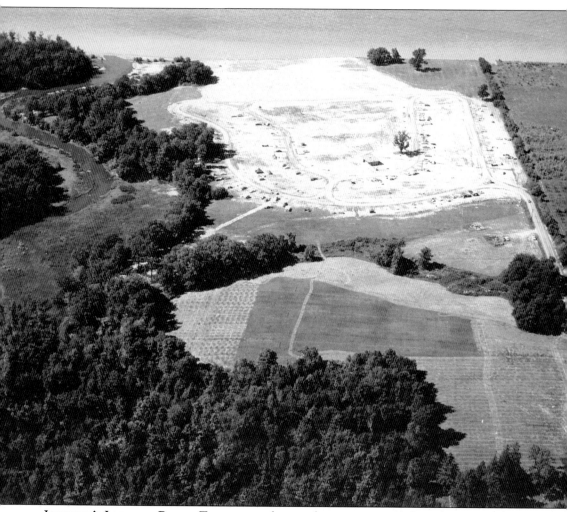

JOHNSON'S LANDING PLACE. Tuscarora settlements became scattered throughout central New York after the notorious Sullivan Clinton campaign, to punish the Haudenosaunee for partial allegiance to the British during the Revolutionary War. A small Tuscarora delegation canoed west on Lake Ontario and settled near Johnson's Landing Place, the outlet of Four-Mile Creek (left side of the photograph). They began to make winter camps on the Niagara Escarpment near the ancient fort of the first Haudenosaunee clanmother, Jikonsaseh. This was the beginning of the settlement of the present Tuscarora Nation. The photograph shows the development of the Four-Mile Creek State Park, near the site of Johnson's Landing Place. (Courtesy Town of Porter Historical Society.)

TUSCARORA MIGRATION.
In 1711, the Tuscarora
asked the commissioners
of Pennsylvania for safety
from wars with the English
colonists and their Cherokee
and Catawba allies. Two
Tuscarora chiefs delivered
eight wampum belts to
memorialize the request for a
new home in Pennsylvania.
The commissioners refused
that request. In 1713, most
of the Tuscarora Nation
left their home in North
Carolina, moving north
until they came into Oneida
territory, where Tuscaroras
dwelled for about 60 years.
(Courtesy Tuscarora
Environment Office.)

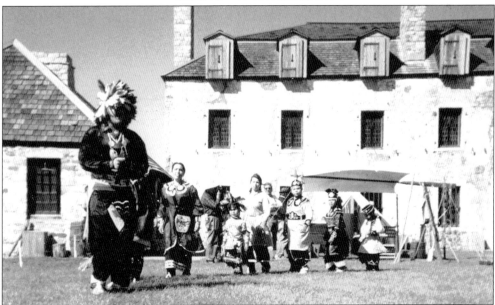

TUSCARORA DANCERS AT FORT NIAGARA REENACTMENT. Tuscarora people lived near Fort Niagara after a devastating military campaign destroyed their villages throughout Upstate New York. In 1779, a total of 5,175 Haudenosaunee men, women, and children were camped outside the fort. Starvation, disease, and supply shortages were common both inside and outside the fort. There were 135 Onondagas and Tuscaroras listed at Fort Niagara in May 1780. (Courtesy Deborah Holler.)

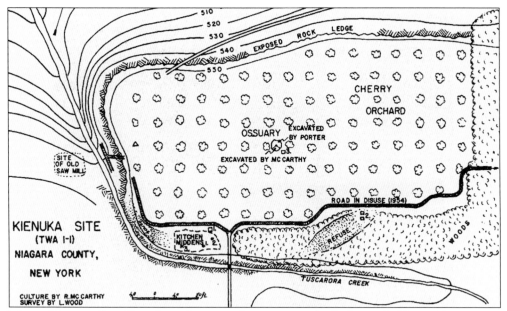

MAP OF KIENUKA SITE. Kienuka, or Gaustreayeh, is an ancient fort built into the Niagara Escarpment, near the northern boundary of Tuscarora. It was the home of Jikonsaseh, the Neutral peace queen who became the first clanmother of the Haudenosaunee. The fort was visited by ethnologist Henry Schoolcraft from the Smithsonian Institute Office of Anthropology. New York State archeologists later created this map of local features. (Courtesy Tuscarora Environment Office.)

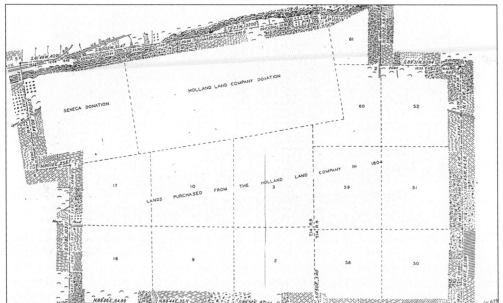

DEPARTMENT OF INTERIOR MAP. In 1804, Gen. Henry Dearborne, United States secretary of war, was authorized by Congress to purchase 4,329 acres from the Holland Land Company for the Tuscarora Nation. This purchase is seen as 13 parcels on the map, a grid measuring one-quarter mile by one-quarter mile imposed by Robert Morris. A 1938 resurvey of Tuscarora, by the Department of Interior, is incorrect due to the omission of Tuscarora lands on the southwestern boundary. (Courtesy Tuscarora Environment Office.)

THE TUSCARORA ACCEPTANCE BELT. In 1714, chiefs of the Five Nations delivered a wampum belt to New York governor Hunter, with the message that the Tuscarora "are come to shelter themselves among the Five Nations: they were of us and went from us long ago, and now are returned and promise to live peaceably among us. And since there is peace now everywhere, we have received them." In 1722, the Haudenosaunee Confederacy, being the Mohawk, Onondaga, Seneca, Oneida, and Cayuga Nations, held a Grand Council at which the Tuscarora Nation made an application, through their brothers the Oneida, to be admitted into the confederacy and become the sixth member nation on the grounds of a common ancestral origin. The application was granted and a wampum belt commissioned. The Tuscaroras made their home in Oneida territory, between the Unadilla, Chenango, and Susquehanna Rivers, for about 60 years. (Courtesy Orrin Dunlop Collection.)

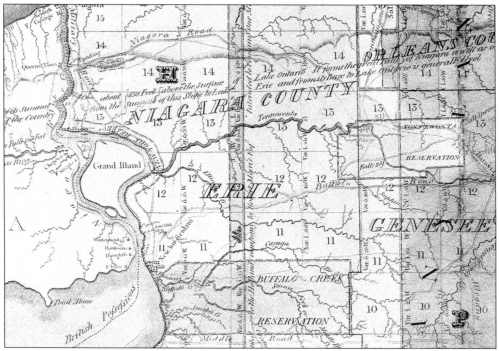

HOLLAND LAND PURCHASE MAP. This map is titled "Map of Morris's Purchase, or West Geneseo, In the State of New York: Exhibiting Part of the Lakes Erie and Ontario, the Straights of Niagara, Chautauque [*sic*] Lake and all the principal Waters, the Boundary lines of the several Tracts of Land purchased by the Holland Land Company." The three square miles of the Tuscarora Nation was established following the Treaty of Big Tree. The map was drawn in 1800 by Joseph Ellicott, agent of the United States government. (Courtesy Tuscarora Environment Office.)

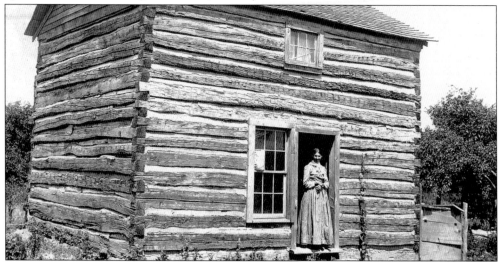

TUSCARORA LOG HOME, 1895. During the War of 1812, the Tuscarora fought against the British invasion of the Niagara area. In 1813, the British managed to invade Lewiston, capture Fort Niagara, and burn the area to the ground, including the Tuscarora settlement. Very few Tuscarora structures survived. Today two log homes are still standing on Susies Lane. (Courtesy Orrin Dunlop Collection.)

HISTORIC WAMPUM BELT. In 1799, the Holland Land Company conveyed a tract of land on the Niagara Escarpment to the Tuscarora Nation. The Tuscarora Nation created the Holland Land Company wampum belt to ratify the conveyance. The belt was found in a Dutch bank vault and was given to the Buffalo Historical Society in 1914. In 1963, the Buffalo Historical Society announced the wampum belt was missing and is still lost today. (Courtesy Niagara Falls Public Library.)

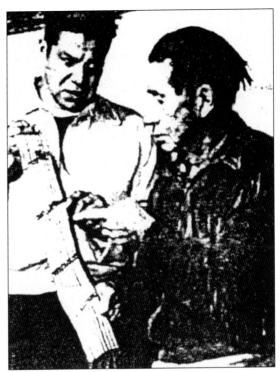

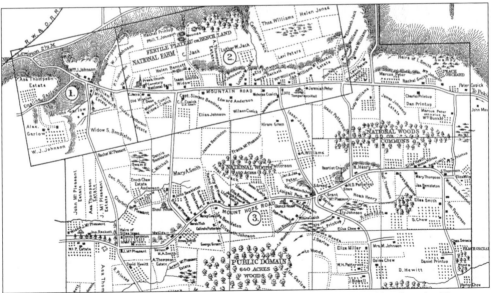

TUSCARORA LAND DEED. The Seneca Nation granted one square mile of land to the Tuscarora Nation shortly after the Treaty at Big Tree, held in Geneseo, New York. Robert Morris, Letchworth philanthropist, reserved and donated two square miles adjacent to the Seneca donation. The Seneca deed is inscribed, "Between the Sachems and Warriors of the Seneca Nation of Indians, of the first part, and the Tuscarora Nation of Indians of the second part, Witnesseth that the said party of the first part for and in consideration of the Love and Affection when they the said Sachems and Warrior of the said Seneca Indians have and bear unto the said Tuscarora Nation." (Courtesy Tuscarora Environment Office.)

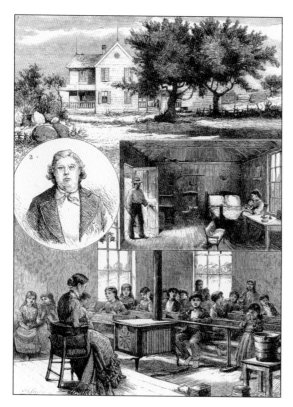

JOHN MT. PLEASANT. The John Mt. Pleasant homestead was one of the first successful farms after the Tuscarora Nation was burned in 1813. This collage of Tuscarora vignettes was featured in *The Graphic* magazine, November 1876. The wood engravings include the home of John Mt. Pleasant, a portrait of Mt. Pleasant, a small Tuscarora cabin, and a view of inside the Indian school. (Courtesy Richard Hill Sr.)

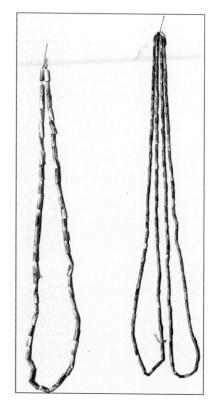

WAMPUM STRINGS. Wampum is still used for record keeping, just like pen and paper are for non-natives. The number of beads, amount of strings, and design of belts are what is important. While at council or ceremonies, orators rarely speak without wampum in their hand to express what they are saying. (Courtesy Orrin Dunlop Collection.)

Two

THE FAMILY ALBUM

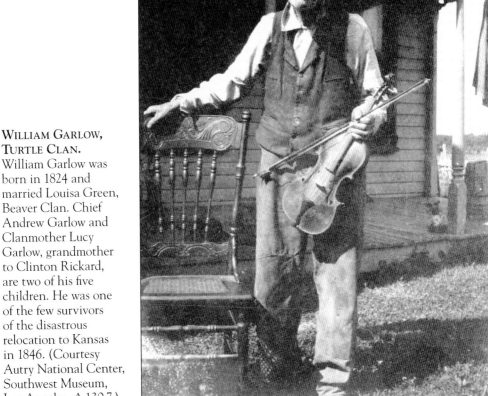

WILLIAM GARLOW, TURTLE CLAN. William Garlow was born in 1824 and married Louisa Green, Beaver Clan. Chief Andrew Garlow and Clanmother Lucy Garlow, grandmother to Clinton Rickard, are two of his five children. He was one of the few survivors of the disastrous relocation to Kansas in 1846. (Courtesy Autry National Center, Southwest Museum, Los Angeles, A.130.7.)

WILLIAMS FAMILY. Seen here are, from left to right, mother Lucinda, Virginia, Minnie, and Lizzie. The father, Thomas, was chief for the Bear Clan. In 1939, his only son, Eleazer, became Sekwari:θre chief for the Turtle Clan. Lucinda was the clanmother for the Turtle Clan. (Courtesy Theodore Williams and family.)

THE PATTERSON FAMILY, C. 1940. Seen here are, from left to right, (first row) with Rover the dog, Donald, Leander, and Kenneth; (second row) Eliza, mother Barbara, Franklin, David, Titus, and father Harry. The five older boys traveled together as a basketball team with their father as the coach. Barbara was the Wolf clanmother, and Harry, chief for the Bear Clan. Later in years, David and Kenneth would become chiefs for the Wolf Clan. (Courtesy Chief Kenneth Patterson.)

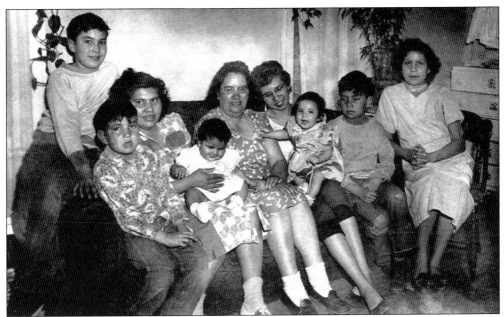

THE RICKARD FAMILY, 1954. In the home of Lenora and Fillmore Rickard Sr. are, from left to right, Kenny, Keith, Margaret, Rosemary, Lenora, Dorene, Ann, Arnold, and Jeanie. The Reeves Photography Studio from North Tonawanda would visit the Rickard family monthly to photography baby Ann in the 1950s. The children in the photograph are of the three sisters Margaret, Dorene, and Jeanie. (Courtesy Dorene Rickard.)

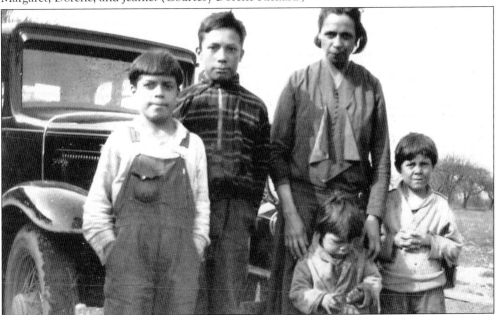

THE GREENE FAMILY, 1930s. Seen here are, from left to right, George, Tom, mother Inez, Loren, and James. The father, George Sr., Beaver Clan, was the son of Hannah Racket. The Racket name eventually turned into the name Rickard, which is still a common name at Tuscarora today. Other common names include Mt. Pleasant, Greene, Printup, Patterson, Hill, Williams, and Pembleton. (Courtesy James and Wendy Bissell.)

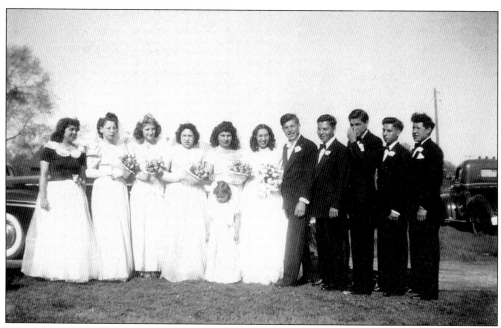

WEDDING OF AMY RICKARD AND ALFRED PRINTUP, 1949. Posing for their wedding pictures are, from left to right, Dorothy Hill, Orelle Johnson, Claire McKie, Doris Jacobs, Margaret Rickard, bride Amy Rickard, groom Alfred Printup, Kenny Rickard, Harrison Printup, Fillmore Rickard, Dallas Wilson, and flower girl Nora Jacobs in the front. (Courtesy Michelle Lewis and family.)

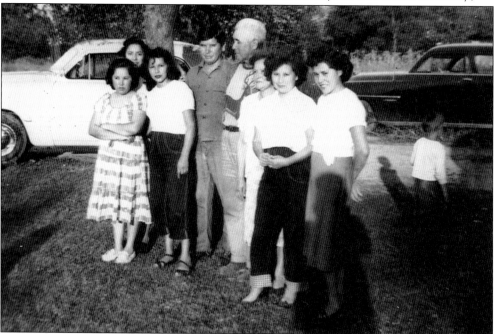

THE HEWITT FAMILY. Pictured here are, from left to right, Flora, Lorraine, Dolores, Arnold, father Pomeroy, mother Laura, Marjorie, and Imogene. In 1955, Arnold became chief of the Bear Clan, replacing the late Jefferson Chew. Flora was the clanmother for the Bear Clan until 2003. She was succeeded by her daughter Linda Hill. (Courtesy Jonathan family.)

MT. PLEASANT FAMILY. Seen here are daughter Clara (left), Eliza "Ruthie," and Chief Edison "Perry" Mt. Pleasant Jr. Perry served in the U.S. Army Air Corps during World War II. In 1984, he was named by Gov. Mario Cuomo the "Indian of the Year" for New York State. He was the last to fill the position of Pine Tree chief when he passed away in 1989 at the age of 70. (Courtesy Susan Patterson.)

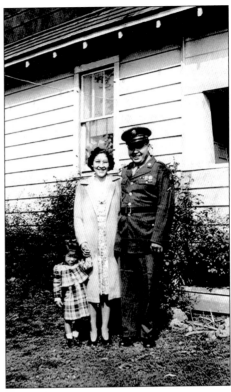

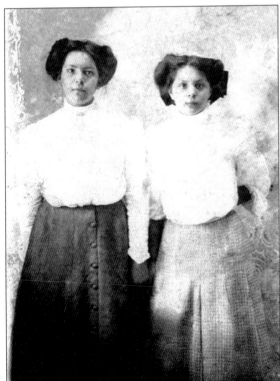

EDNA JOHNSON AND JOSEPHINE MT. PLEASANT, C. 1910. Edna Johnson, Onondaga, was the daughter of Jesse Patterson and Leah Thompson. She married Seymore Johnson, who attended the Hampton University in Hampton, Virginia, and became a farmer on Walmore Road. Josephine Mt. Pleasant, Bear Clan, was the daughter of Grant Mt. Pleasant and Minerva Garlow. (Courtesy Chief Kenneth Patterson and family.)

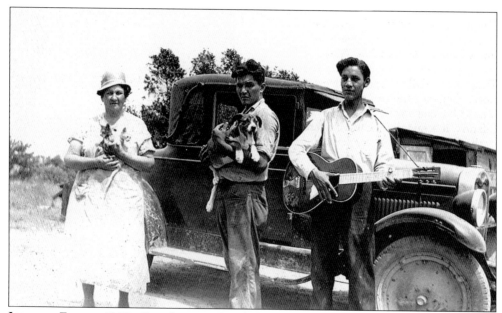

JOHNSON FAMILY, 1930S. Seen here are, from left to right, Emily Johnson, Charlie Johnson, and Harold Williams. Dennis Johnson, Beaver Clan, married Emily in 1907 at Tuscarora. Emily is the sister to Chief Willie Chew and aunt to Barbara Chew, wife of Harry Patterson. (Courtesy Tuscarora Environment Office.)

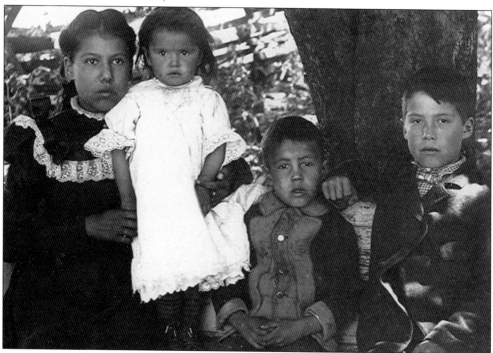

GREENE FAMILY, 1899. The children of Hiram Greene and Emma Johnson are, from left to right, Violetta, Eulalia, Ralph, and Elton Greene. Violetta married Roy Hill, who owned a popular store and filling station on Upper Mountain Road. Elton was a well known bass singer and a lay pastor in the Tuscarora Baptist Church. (Courtesy Orrin Dunlop Collection.)

JEREMIAH PETERS, 1920S. Jeremiah Peters was born in 1842 and married Emily Garlow, Beaver Clan. They raised five children and lived near the Temperance Hall on Upper Mountain Road. He joined the Union in the Civil War with Company D, 132nd New York Infantry. It is said that he was captured by the Confederates during the war but escaped and returned to Tuscarora without returning to his unit, unaware that he was still enlisted. (Courtesy Lulu Benedict collection.)

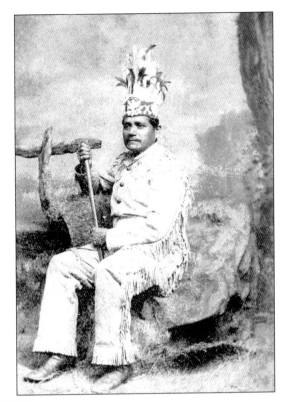

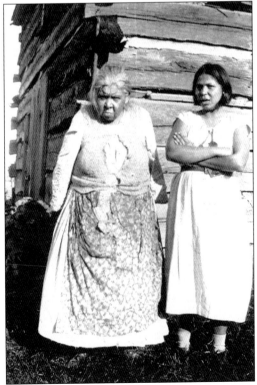

MOTHER AND DAUGHTER, 1938. Anna Thompson, Eel Clan, and her daughter Flora Thompson stand by their log home. Anna was born in 1876 and is the great-granddaughter of Chief William Chew and Eliza Thompson. (Courtesy Susan Patterson.)

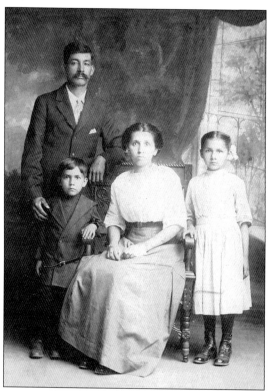

JONATHAN FAMILY, 1914. Edward Jonathan, Beaver Clan, married Edith Hill, Snipe Clan. Their two children are Edmund and Louise. They lived on Upper Mountain Road near Jacobs Spring, across the road from Jeremiah Peters. (Courtesy Jonathan family.)

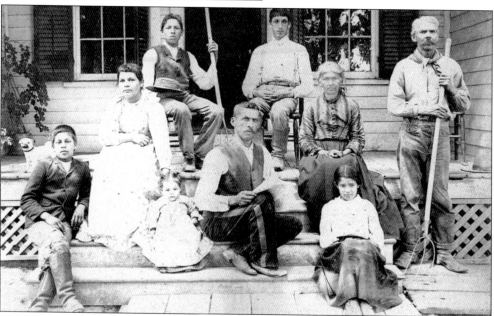

MT. PLEASANT ESTATE GATHERING, C. 1896. Three generations of family gather on the front porch of the Mt. Pleasant Estate, located on Moyer Road. They are, from left to right, (first row) unidentified girl; (second row) Sampson Pembleton, baby Barbara Chew, and David Chew; (third row) Ruth Patterson, Elizabeth Mt. Pleasant, and James Patterson; (fourth row) two unidentified men. (Courtesy Chief Kenneth Patterson.)

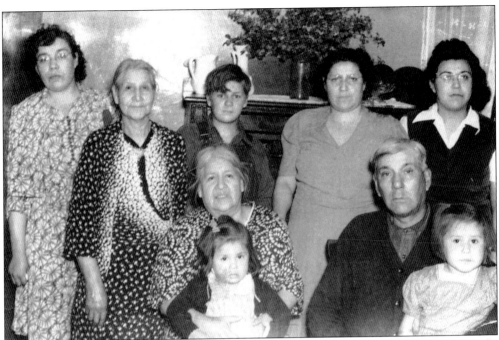

A FAMILY GATHERING. Multigenerational families in one home are standard at Tuscarora. In this photograph are, from left to right, (first row) Karen Rickard and Beverly Rickard; (second row) Margaret Mt. Pleasant and Nelson Mt. Pleasant; (third row) Dorothy Crouse, Sophronia Thompson, EC Mt. Pleasant, Beulah Mt. Pleasant, and Ethel Zomont. (Courtesy Norton Rickard and family.)

JULIA GARLOW, BEAR CLAN. Julia Garlow married Titus Patterson, Onondaga, in 1887 and raised five children. Clinton Rickard and Elizabeth, the daughter of Julia and Titus, married at the Patterson home on Upper Mountain Road about 1917, while a measles epidemic was sweeping through Tuscarora. Julia was the daughter of Alexander Garlow, Turtle Clan, and Lucy Thompson. (Courtesy Lulu Benedict collection.)

GRANT MT. PLEASANT AND FAMILY. Chief Grant Mt. Pleasant, Turtle Clan, stands in front of his home. The estate was eventually owned by his son Hamilton, who passed away in 1964 at the age of 67 years old. Chief Mt. Pleasant is standing to the left of the photograph with his wife, Minerva Garlow, and the beautiful grounds of his home. (Courtesy Autry National Center, Southwest Museum, Los Angeles, A.130.19.)

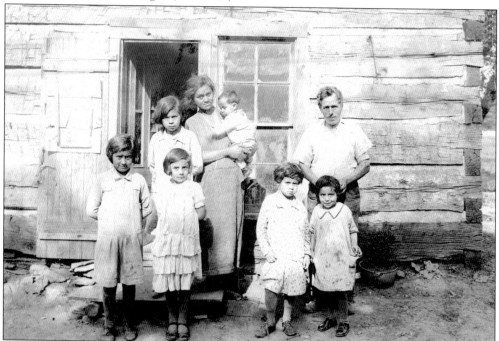

CUSICK FAMILY OF EIGHT, 1930. The Cusicks, Snipe Clan, lived on Susies Lane in a small log home. Pictured here are, from left to right, (first row) Emma, Eliza, Nancy, and Lucy; (second row) Susan, mother Susan, Webster, and father Webster Sr. (Courtesy Jonathan family.)

Three

CHIEFS AND CLANMOTHERS

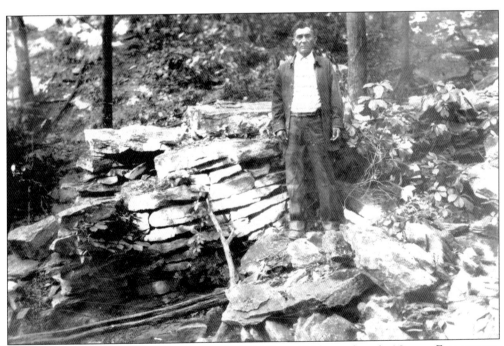

DANIEL SMITH, 1948. Daniel Smith is at the "Old Sawmill," located on the Niagara Escarpment. According to the 1797 Treaty of Big Tree, the United States agreed to build a sawmill on each participating reservation. The workers contracted to do the work were not too particular if the streams carried sufficient water to operate the mills. The old sawmill seems to show no evidence that it was ever used. (Courtesy National Philosophical Society.)

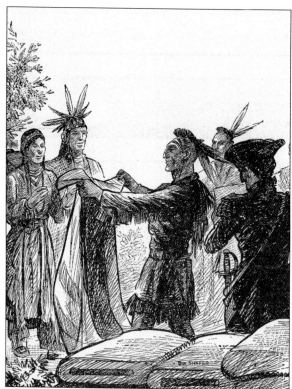

TREATY PROVISIONS. In the 1794 Treaty of Canandaigua, a provision was made to allocate $4,500 for goods to be divided among the Six Nations of the Haudenosaunee. Now more than 200 years later, the Tuscarora Nation continues to receive annuity cloth from the United States government on a yearly basis. The cloth is proof that the articles of the treaty are, and will remain, in perpetuity. (Courtesy Tuscarora Environment Office.)

ANNUITY CLOTH. Standing in the Council House cutting annuity cloth in 1968 are Doris Hudson (left), Turtle clanmother, and Hattie Williams, Beaver clanmother. In 1954, the United States government offered the Tuscarora Nation a $150,000 lump-sum payment in lieu of the annuity cloth required by the 1794 Treaty of Canandaigua. The Tuscarora Nation turned the money down under the premise that the substitution would invalidate a treaty provision between the United States and the Tuscarora Nation. (Courtesy Theresa Wilson.)

COURT CASE ABOUT CHIEFS, 1895. Lucy Patterson waits on the steps of the commissioner's office on Bath Island. Inside, Hon. J. R. Jewell, Indian agent, was presiding over a case of chieftaincies at Tuscarora. In 1890, the Council of Chiefs decided to elect an annual president from within their body. This change led to more problems than good and was eventually eliminated. (Courtesy Orrin Dunlop Collection.)

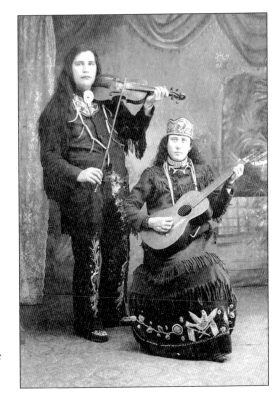

PINE TREE CHIEF. Chief Andrew Garlow, Beaver Clan, was born in 1865. Beginning in 1914, he served as Pine Tree chief, a position chosen by the Council of Chiefs and not by the clans. Pine Tree chiefs are "helpers" who have demonstrated commitment of service to the council. Garlow enjoyed playing music and was once part of the Buffalo Bill's Wild West Show. (Courtesy Lulu Benedict collection.)

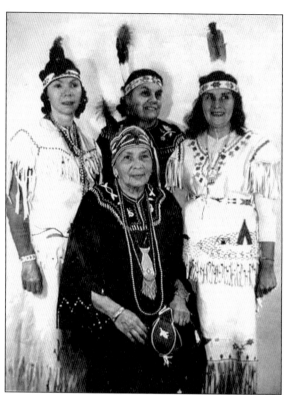

PEMBLETON FAMILY CLANMOTHERS. Harriett Pembleton is sitting with three of her daughters behind her; (from left to right) Louise, Doris, and Shirley. Harriett, Louise, and Doris were all Turtle clanmothers at Tuscarora. Each clan is headed by a clanmother and her job is to select the male leader, the chief. The chiefs represent their clan and seek consent from the clanmother. She is also responsible for calling clan meetings and maintaining harmony and balance among her clan and nation. (Courtesy Richard Hill Sr.)

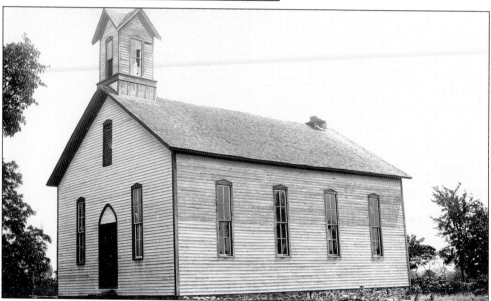

TUSCARORA COUNCIL HOUSE. The old council house burned in the spring of 1935. That same year, the United States government attempted to replace the traditional government of Tuscarora through the Federal Indian Reorganization Act with an elective tribal government. The Tuscarora Nation renounced those efforts and retained the council of chiefs and clanmothers. Today Tuscarora is one of four Haudenosaunee communities in the United States that still operates under their original form of traditional governance. (Courtesy Orrin Dunlop Collection.)

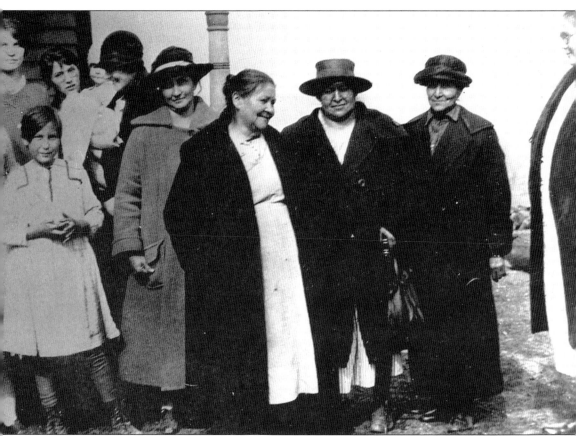

CLAN MEETING BEFORE A CONDOLENCE CEREMONY, 1927. The condolence of Chief Jonathan Printup and Chief William Chew was reported in the *Buffalo Evening News* the following day. The newspaper said, "from early morning until late at night, the ceremonies continued at the reservation here Saturday. Fully 500 persons attended including a large number of paleface brothers. In the council of chiefs that officiated at the ceremonies sat representatives of the entire Six Nations in the Iroquois confederacy." Their clanmother was Rachel Mt. Pleasant, "who escorted Jonathan Printup to the front of the council and handed the belt of wampum to Sachem Andrew Gibson of the Onondagas, head chief of the Haudenosaunee, thus indicating that her choice has been made." Seen here are, from left to right, (first row) Avis Doxtater, Margaret Mt. Pleasant, Sophronia Thompson, and Leah Green; (second row) unidentified girl and Emily Hill; (third row) Amy Rickard, Arlene Rickard, Wesley Patterson, and Alta Patterson. (Courtesy Caroline Henry.)

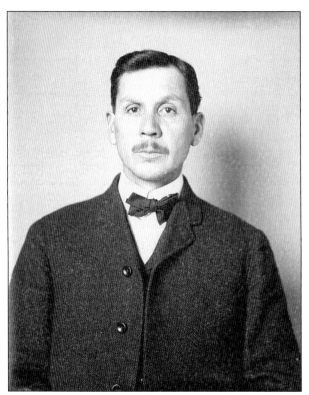

TURTLE CLAN CHIEF. Chief Grant Mt. Pleasant, in this 1900 photograph, was also known as Ne-no-kar-wa. He was already a chief by 1890 at the age of 24. He was married to Minerva Garlow, the brother to Frank Pierce, a minister for more than 50 years at Tuscarora. Chief Mt. Pleasant passed away in 1929 at the age of 62, the same year as two other chiefs, Chief Luther Jack and Chief Markus Peters. (Courtesy Niagara Falls Public Library.)

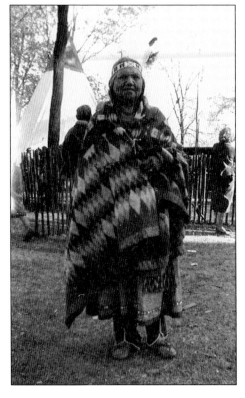

BEAR CLANMOTHER, 1958. Cinderella Printup is at one of the many public events she attended as a Tuscarora ambassador. She was born at Tuscarora on June 20, 1885, and was the mother of eight children. She was also the "mother" of many prominent non-Tuscaroras honorarily adopted into her Bear Clan because of their contributions to the Native American cause. She was the oldest clanmother at Tuscarora when she passed away in 1974. (Courtesy Niagara Falls Public Library.)

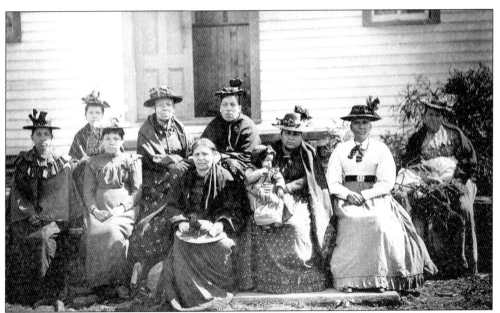

WOMEN AT CONDOLENCE, 1898. Sitting outside the Council House are, from left to right, (first row) Diasy Mt. Pleasant, Carolyn Pembleton Jones, Helen Jones, unidentified child, Ida Hill, Susan Thompson, and Margaret Hill; (second row) Mrs. Silas Hewitt, Eliza Greene, and Hannah Green. When a chief has passed on and a new one is stood up by his clan and clanmother, a condolence ceremony is conducted to pass the chieftainship to the new chief. (Courtesy Orrin Dunlop Collection.)

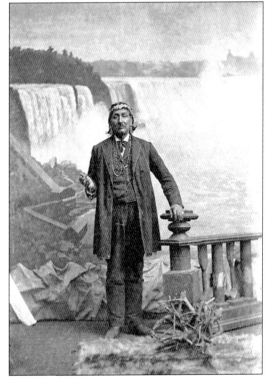

DA-QUAR-TER-ANH, C. 1896. Chief Daniel Printup, Wolf Clan, was the father of seven children with his wife Elizabeth Chew. Daniel was the son of Chief Jonathan Printup, one of those who executed a deed in the former homelands of North Carolina in 1831. Elizabeth was the daughter of Sekwari:θre Chief William Chew, 1 of 10 Tuscaroras who signed the Buffalo Creek Treaty in 1838. (Courtesy Lulu Benedict collection.)

CHIEF LUTHER JACK ALONG THE NIAGARA RIVER, C. 1895. Chief Luther Jack was made a chief of the Wolf Clan when he was 13 years old by the women of his clan. The United States Congress passed the Dawes Act of 1887 in an attempt to make Native Americans into United States citizens. In 1888, the New York State Assembly began investigating whether they could impose the principles of the Dawes Act on all of New York State's reservations. That same year Chief Jack testified at the Whipple Committee hearings held at Tuscarora: "Well, as soon as we become citizens the land will be divided, and by so doing I think there is a curse to the Nation." The Whipple Committee report recommended that Tuscarora lands be divided up into individual ownership and that democratic elections be held. The state's attempts failed at Tuscarora, where a traditional government still operates today. J. S. Whipple, chairman of the committee, was also a state assemblyman who represented the city of Salamanca, which was built on Seneca lands. (Courtesy Orrin Dunlop Collection.)

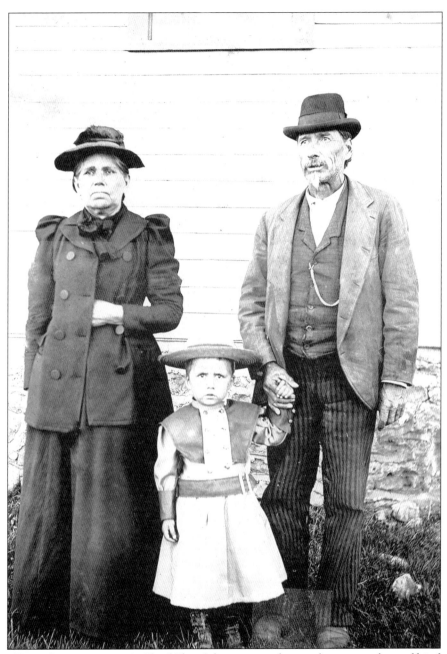

Chief Elias Johnson, 1896. Chief Elias Johnson, standing with two members of his family, was a chief of the Bear Clan. He testified in 1888 to the Whipple Commission hearings held at Tuscarora that he was once a chief, but was deposed by the Onondagas. When asked whether the laws of the Onondagas governed Tuscarora, Chief Johnson replied, "Yes sir; that is, concerning the authority of the Chiefs; they are to install and depose, that is all; and all cases or matters in our Council here they have nothing to do with." He was asked by the interviewer whether there was woman suffrage in his tribe and he replied, "Yes, sir; we are ahead of the white folks, they are just agitating it." The Whipple report was published in 1889, in a failed attempt to assimilate Native Americans in New York State. (Courtesy Orrin Dunlop Collection.)

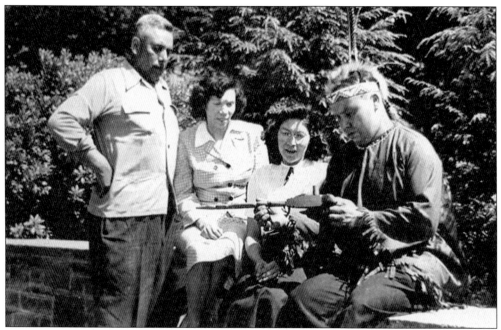

TUSCARORA LEADERSHIP. Seen here are, from left to right, Beaver chief Noah Henry, Turtle clanmother Louise Henry, Wolf clanmother Eliza Mt. Pleasant, and Pine Tree chief Edison Mt. Pleasant Jr. They are four representatives of their respective clans on the council. The chiefs' positions are for life, or until they are deemed unfit to hold the position by their clanmother. (Courtesy Richard Hill Sr.)

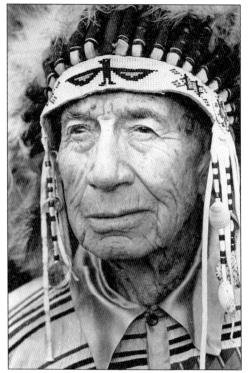

CHIEF ELTON GREENE. Elton Greene and John Hill became chiefs in 1946, along with six other Tuscarora chiefs, in a condolence presided over by Onondaga chief Isaac Lyons. At the time of condolence, a chief receives a short string of wampum beads to confirm his title, and then they are told to have a skin that is seven layers thick so that harsh words and criticism will not create malice in their hearts towards their own people. (Courtesy Lewiston Historical Museum.)

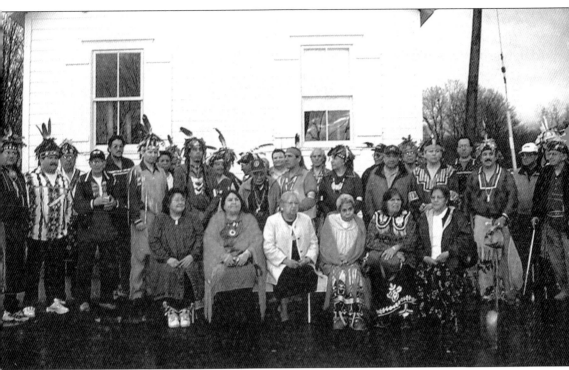

CONDOLENCE AT ONONDAGA, 1998. Haudenosaunee chiefs and clanmothers gather at the Onondaga longhouse to condole the title of todadaho to Sidney Hill (second row, fifth from the left). Sand Turtle clanmother Susan Patterson (first row, second from left), Turtle clanmother Mary Lou Printup (first row, second from right), and Beaver chief Stuart Patterson (third row, third from the right) are among the many Tuscaroras who attended the eight-hour ceremony. The younger brothers are Cayuga, Oneida, and Tuscarora. The elder brothers are Seneca, Onondaga, and Mohawk. During this ceremony, all Haudenosaunee gather to mourn the one who once held the Todadaho title. Then the younger brothers condole the elder brothers. (Courtesy Chief Stuart Patterson.)

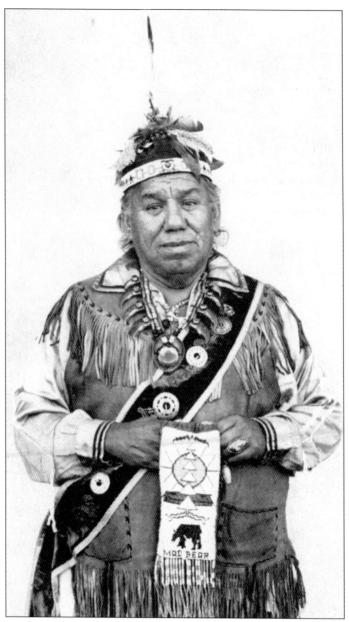

WALLACE "MAD BEAR" ANDERSON. Wallace "Mad Bear" Anderson was an advocate of Haudenosaunee issues, but more specifically for Tuscarora Issues. He was involved in the fight against the New York State Power Authority, and for the eviction of non-Native Americans living in trailer parks at Tuscarora. Wallace Anderson's dedication to human and Native American rights has led him to the United Nations, Native American occupation of Alcatraz, Fidel Castro's Cuba, and Europe. He was of the generation of Native Americans in the 1950s who led unity caravans, the precursor to the Red Power movement of the 1970s. Anderson was of the Bear Clan and sometimes referred to in public as a medicine man. He is featured in many publications including *Rolling Thunder* by Doug Boyd, *Apologies to the Iroquois* by Edmund Wilson, and *Mad Bear: Spirit, Healing, and the Sacred in the Life of A Native American Medicine Man* by Doug Boyd. He passed away at the age of 58. (Courtesy Tuscarora Environment Office.)

Four

THE TUSCARORA
WAY OF LIFE

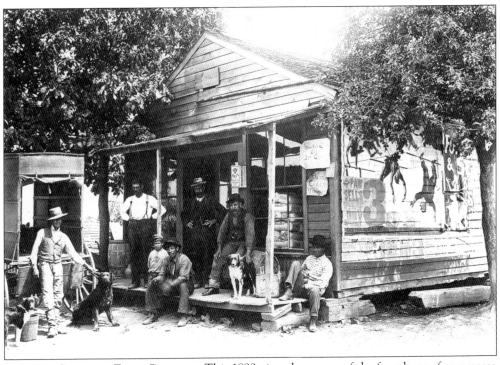

GENERAL STORE AT FOUR CORNERS. This 1899 view shows one of the few places of commerce at that time. The store burned down a few years later in 1905 at Walmore Road and Mount Hope Road. The 1892 United States census stated Tuscarora was producing 3,007 bushels of wheat, 1,143 bushels of potatoes, 234 bushels of beans, and more than 9,100 bushels of other agricultural products a year. (Courtesy Orrin Dunlop Collection.)

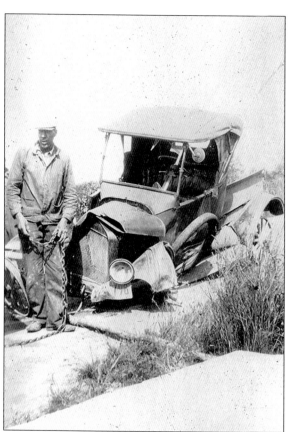

CAR WRECK ON WALMORE ROAD.
The narrow dirt roads were difficult to traverse with the new automobile, resulting in many crashes and accidents. Here Jim and Vernon Hill are about to be towed home after their car accident on the S-bend on Walmore Road. In the 1930s, after the automobile deeply rutted the roads, a committee was formed to improve the roads with paving. (Courtesy Tuscarora Environment Office.)

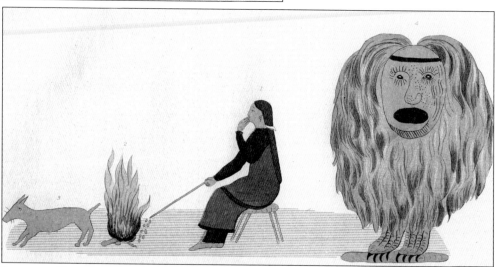

IROQUOIS DRAWING, THE FLYING HEAD, 1827. David Cusick was the founder of the Early Tuscarora Realist style of watercolors with his brother Dennis Cusick in the early 19th century. David was born about 1785, became a doctor, and published a 28-page book, *Sketches of Ancient History of the Six Nations*, in 1827. *The Flying Head* is one of several woodcuts used in his 1828 second edition, other drawings include: *The Stone Giants, A War Dance*, and *Atotarho*. (Courtesy Tuscarora Environment Office.)

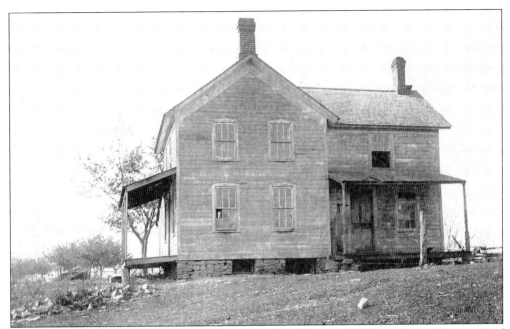

CHIEF THOMAS WILLIAMS RESIDENCE, C. 1895. Chief Thomas Williams, Bear Clan, was 1 of 10 chiefs who passed a resolution banning gambling at Tuscarora in 1885. His home on Susies Lane was atypical for Tuscarora, considered affluent for those days. To this day, a few of these homes are still in use by the same families that built them more than 100 years ago. (Courtesy Orrin Dunlop Collection.)

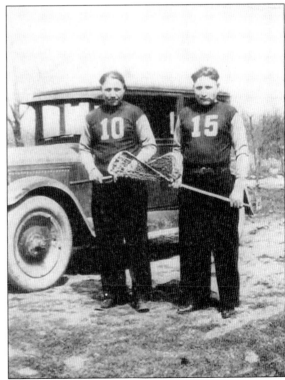

LACROSSE PLAYERS, LATE 1930S. Harry Jacobs Sr. (left) and Ellwood Jacobs Sr. pose with their prized lacrosse sticks and uniforms. Lacrosse has its roots back to the creation of the Haudenosaunee. Each generation of Tuscarora lacrosse has an oral history of the great games, the best players, and the fierce competitions. (Courtesy Eugene and Elva Greene.)

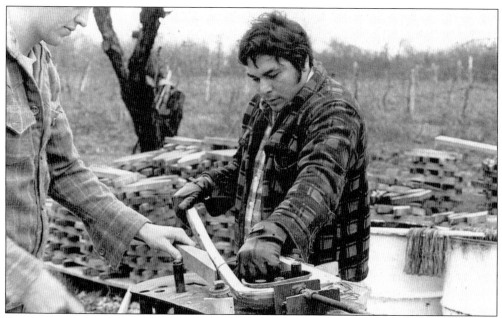

TUSKEWE KRAFTS, 1970S. In 1971, John Wesley Patterson started a successful hickory-wood lacrosse stick business called Tuskewe Krafts. At the height of business, his factory was turning out 10,000 wooden lacrosse sticks a year. Tuskewe Krafts continues to produce world-renowned wooden lacrosse sticks in the old red barn on Susies Lane. Eugene "Oscar" Moses is bending the stick in the shape of the lacrosse head to the 20 degree angle that is required. (Courtesy Tuskewe Krafts.)

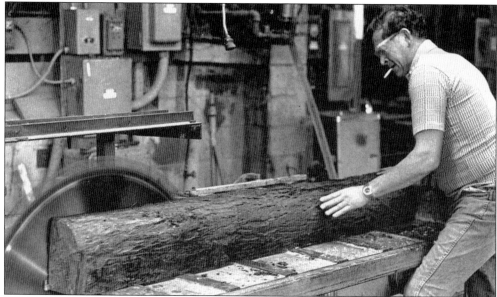

MAKING LACROSSE STICKS. John Wesley Patterson, known as Wesley, left Tuscarora to attend Springfield College as a record setting lacrosse player. After serving in the military, he became a high school gym coach in Maryland and is largely credited for starting the successful lacrosse programs in Maryland. Currently the John Wesley Patterson Award is handed out to the MVP at the International Women's Lacrosse Association World Cup. He was inducted posthumously into the National Lacrosse Hall of Fame in 2000. (Courtesy Tuskewe Krafts.)

LACROSSE BOX. Located on Walmore Road, north of the Red and White Store at the corner of Mount Hope and Walmore Roads, the box was a place of entertainment and socializing. It was common to attend a game, bring a picnic, and enjoy everyone's company. The children were treated to ice cream, hamburgers, and the occasional soda. During the winter, children would use the lacrosse box for ice skating. (Courtesy Richard Hill Sr.)

LACROSSE TODAY. Tuscarora boys have many outlets to play lacrosse on the nation, as well with local teams. Popular options to play at are Niagara-on-the-Lake, Hyde Park, and Niagara-Wheatfield High School. The lacrosse program at Niagara-Wheatfield was the first in Niagara County, starting in 1977, and has featured many successful Tuscarora lacrosse players. (Courtesy Niagara Falls Public Library.)

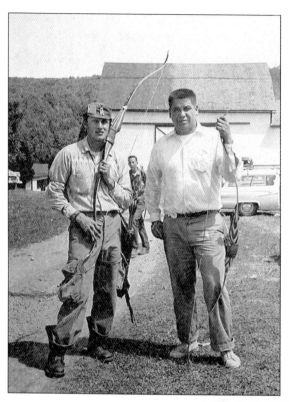

SEVEN-CLAN BOWMEN, C. 1958.
Theodore Williams and Harrison
Printup (left) stand in front of the
old red barn on Susies Lane. In 1956,
Williams and Printup started the
7-Clan Archery with Howard Hill,
Fillmore Rickard, Truman Johnson,
and Larry Robinson. The archery
course is located behind the barn.
After a few years, they eventually built
a clubhouse. Williams (below) designed
and built the sign for the 7-Clan
Bowmen still located at the road
today, directing one to the archery
course. The club promoted archery and
shooting for young ones. (Courtesy
Theodore Williams and family.)

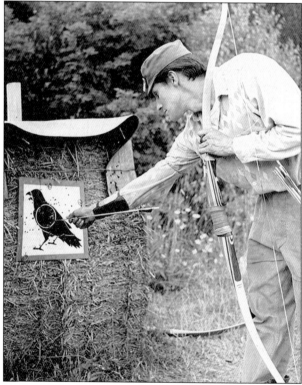

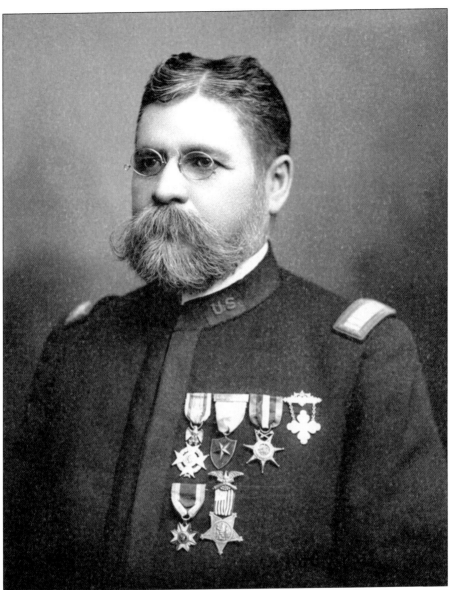

LT. CORNELIUS CUSICK. Lt. Cornelius Cusick was born in August 1835 to James and Mary Cusick, and was the grandson to Nicholas Cusick, who was the bodyguard and interpreter for Marquis de Lafayette. Cornelius volunteered to serve for the Union in the Civil War and was promoted to first lieutenant a year later. He was 1 of 23 Tuscaroras to volunteer that year for service, and he became recognized as the leader of the Tuscarora Company. It is stated that he was the most important Haudenosaunee commander of Native American servicemen during the Civil War. During the Civil War, Cusick was on General Sherman's March to the Sea, and in the Sioux War of 1876, he fought with General Miles against Crazy Horse. His proficiency in eight Native American languages and recognized authority on Haudenosaunee culture led to his appointment as assistant director of archeology and ethnology for the Columbian Exposition in Chicago in 1892. In 1904, Cusick was buried with military honors at Old Fort Niagara, only a short distant north of Tuscarora. He is not buried on the nation due to his fighting against other Native Americans, specifically the Sioux. (Courtesy Niagara Falls Public Library.)

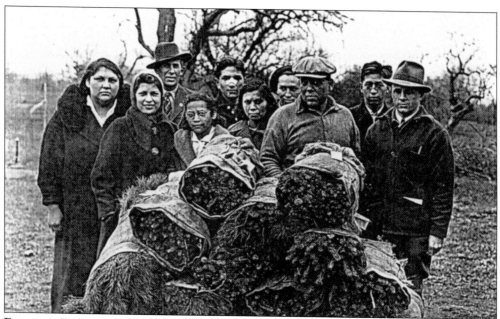

FORESTRY PROJECT, 1938. The Tuscarora 4-H Club planted 80,000 trees in Niagara County. Many of the trees can still be seen today. Planting large stands of pine trees was typical of the Public Works Administration era. Seen here are, from left to right, (first row) Dorothy Printup, Lucille Henry, Louise Henry, Noah Henry, and John Stooky, 4-H agent; (second row) Lucy Chew, unidentified, Johnny Hill, unidentified, and Bill Rickard. (Courtesy Chief Kenneth Patterson and family.)

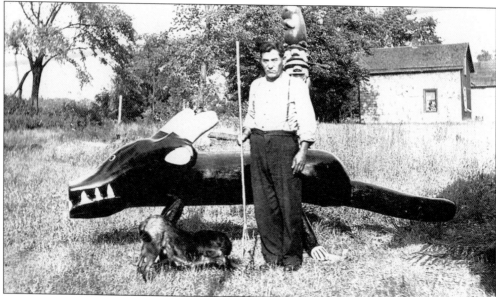

THE STRANGEST ANIMAL, 1945. Dan Smith appears with two wood carvings at his home on Mount Hope Road. His home, not in this photograph except for its shadow on the right, was a cabin built in 1797 and moved from Chew Road to Dan Smith's before 1930. His carving of the turtle-like creature, from a Tuscarora legend, was popular and attracted many people to his home. (Courtesy James and Wendy Bissell.)

ROAD NEAR RICKARD'S HOME, 1948. Blacknose Spring Road was a dirt road heading north to Ransomville. It passed Empire Limestone Quarry and the Blacknose Spring on the northeast side of Tuscarora. This spring received its name from a Beaver chief that once lived there long ago, named Chief Blacknose. He acquired his name because of a black spot on his nose. (Courtesy National Philosophical Society.)

THE OLD BURIAL GROUND, 1939. Titus Patterson is standing in the old cemetery, which was unkempt and in disarray. In 1950, Kenneth Patterson renovated the cemetery with the authorization of the council. He expanded the cemetery, leveled the ground, and created the Mount Hope Cemetery that exists today. (Courtesy Susan Patterson.)

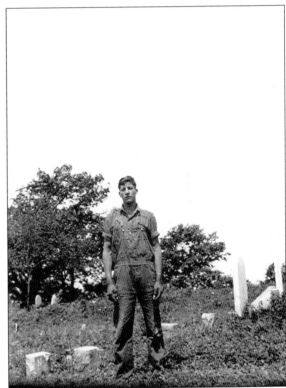

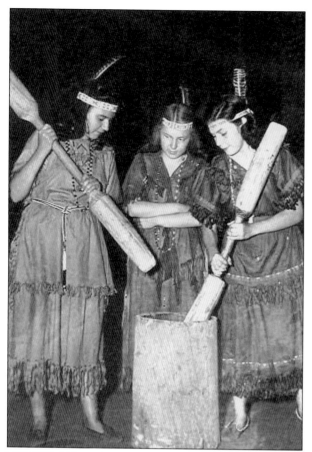

THE 4-H CLUB PLAY. Tuscarora youths performed in many plays, skits, singing groups, and dance troops to illustrate the Tuscarora culture with the 4-H Club. The play *As the Great Spirit Wishes* was an award-winning drama about two children of warring chiefs who fall in love and wish to marry. The women in the play step in and insist that the chiefs stop fighting so the children can marry in peace. In the photograph (left) from left to right are Donna Woodbury, Ann Ruth Mt. Pleasant, and Frieda William. Another popular play, called *Into the Setting Sun* (below), was well received by audiences at such places as local churches, auxiliary clubs, fairs, and schools. Seen below are, from left to right, Sandy Pembleton, unidentified, Ann Ruth Mt. Pleasant, Donna Woodbury, Frieda Williams, Joseph Woodbury, Rose Printup, and unidentified. (Left, courtesy Richard Hill Sr.; below, courtesy Tuscarora Language Committee.)

THE 4-H CLUB SING-ALONG. The first 4-H Club in Niagara County was started at Tuscarora. As other 4-H chapters grew, the Tuscarora 4-H often held barn dances with the new chapters. The women pictured are, from left to right, Caroline Woodbury, Jean Smith, Ann Ruth Mt. Pleasant, Rose Printup, Donna Woodbury, and Dorothy Printup. (Courtesy Richard Hill Sr.)

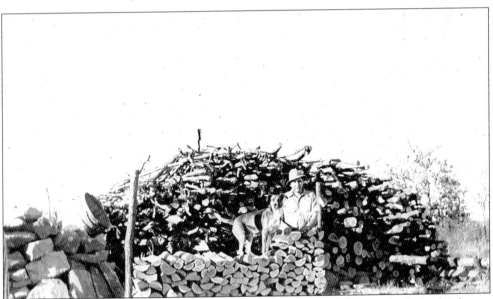

COLLECTING WOOD. Dennis Johnson stands with his dog and the wood pile for his home. The main source of heat for homes was wood. During the early 1900s, Tuscarora had a wood inspector, who was responsible for collecting wood taxes from non-Native settlers on the Tuscarora Nation. The Tuscarora Nation members would receive more land if they showed careful stewardship over the wood stand on their land and used only what they needed. (Courtesy Tuscarora Environment Office.)

ROADSIDE BEADWORK, C. 1940. Delilah Bissell (left) and her granddaughter Dorene Williams stand by a bark stand in front of the home of Viola Russell. They would sell beadwork and souvenirs to tourists visiting Tuscarora, who were looking for a glimpse into the Native American life. Tootsie's mother, who lived across the road, also owned a bark stand. A bark stand was a small roadside booth that was used to sell beadwork. It was sided with bark, which was harvested at Tuscarora. (Courtesy Susan Patterson.)

CHIEF ELIAS JOHNSON AT NIAGARA. Chief Elias Johnson, Bear Clan, is the author of *Legends, Traditions and Laws, of the Iroquois, or Six Nations, and History of the Tuscarora Indians*, published in 1881. In his preface he says, "to animate a kinder feeling between the white people and the Indians, established by a truer knowledge of our civil and domestic life, and of our capabilities for future elevation, is the motive for which this work is founded." (Courtesy Orrin Dunlop Collection.)

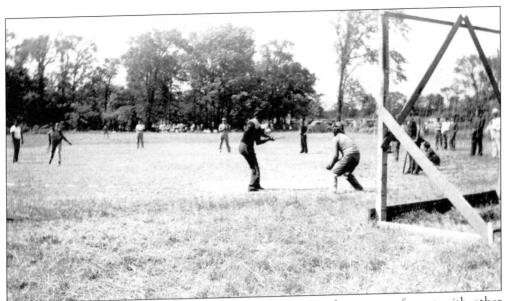

SOFTBALL GAME WITH THE SENECAS. It is common to play games of sport with other Haudenosaunee nations, especially in lacrosse, baseball, snowsnake, and in this photograph, softball. These inter-nation games reinforce relationships and allow them to gather in a social atmosphere. This game is on Walmore Road, north of Mount Hope Road. (Courtesy Suzanne Goater.)

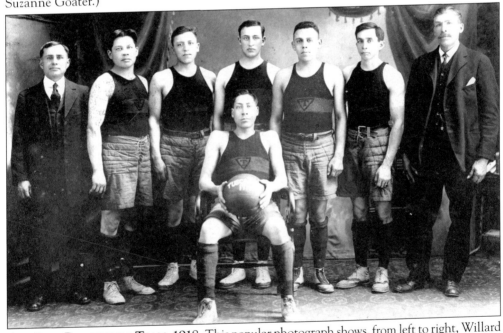

ALL-STAR BASKETBALL TEAM, 1918. This popular photograph shows, from left to right, Willard Gansworth, Alvin Printup, David Sylvester, Wesley Patterson, Harry Patterson (seated), Noah Henry, Orsamus Gansworth, and Titus Patterson. The team used the old council house for its games before the gymnasium was built in the 1920s. The council house was inadequate to use because it had two kerosene chandeliers and two wood stoves at either end. (Courtesy Richard Hill Sr.)

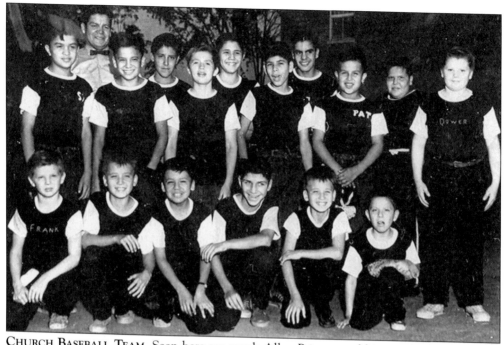

CHURCH BASEBALL TEAM. Seen here are coach Allen Printup and his popular baseball team in the 1950s. From left to right are (first row) Frank Davis, Richard Billings, Bob Gansworth, Walter Zomont, Robert Billings, and Kimball Patterson; (second row) Simon Brascoupe, Neil Gansworth, Thomas Mt. Pleasant, James Hill, Pat Brascoupe, and Dower Davis; (third row) coach Allen Printup, William Patterson, Roger Jacobs, Theodore Printup, and Marlen Printup. (Courtesy Richard Hill Sr.)

U.S. OLYMPIAN. Franklin Mt. Pleasant, Bear Clan, was born in 1884. He attended Carlisle Indian School, where he played piano and was a football star with Jim Thorpe. Before attending Dickinson College in 1908, Franklin represented the United States in the London Olympics of 1908. He placed sixth in the long jump and triple jump. In 2004, he was inducted into the Dickinson College Sports Hall of Fame. (Courtesy Tuscarora Environment Office.)

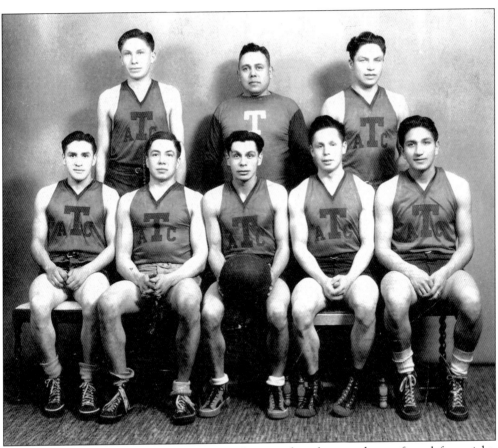

Tuscarora Basketball Team, c. 1940. Seen in this photograph are, from left to right, (first row) Tracy Johnson, John Gansworth, John Pembleton, Elton Mt. Peasant, and Johnny Hill; (second row) Vincent Printup, Noah Henry, and Murray Printup. Basketball teams from Tuscarora were early participants of local leagues in Niagara County. Some of the first teams Tuscarora played were Niagara University, German Orioles, YMCA, Armory, and Barker. Below is a score sheet from a basketball game in 1919 between the Tuscaroras and the Black Rocks. The game was played at the Tuscarora Council House. The Tuscaroras players included Wesley Patterson, Roy Hill, Harry Patterson, Ray Gansworth, John Printup, and Alvin Printup. (Above, courtesy Bryan Printup; below, courtesy Chief Kenneth Patterson and family.)

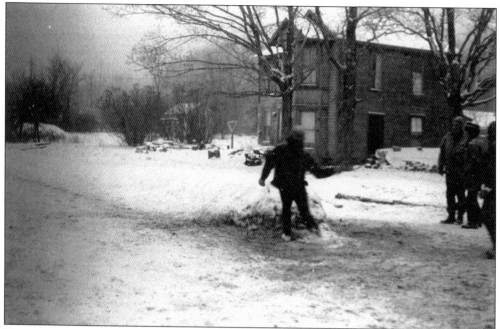

THROWING SNOWSNAKES. A crowd of men watch a Tuscarora snowsnake thrower approach the track. Snowsnake is a Haudenosaunee game played by men only, who throw wooden "snakes," about three to four feet long. The track is formed of ice and snow created by dragging logs. (Courtesy Fillmore Rickard.)

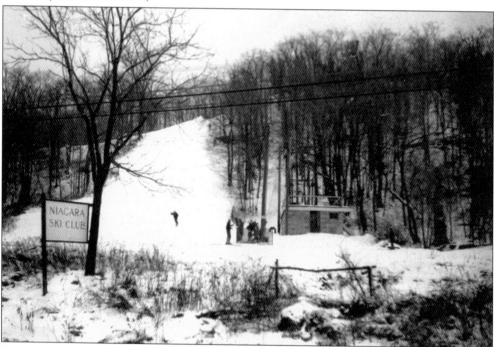

NIAGARA SKI CLUB. The ski hill was located off Route 104 on the northwestern corner of Tuscarora. There was a warming house and ski lift on site. Gary Patterson operated the ski hill until the late 1960s. The warming hut can still be seen today. (Courtesy Chief Kenneth Patterson.)

SUSAN THOMPSON IN A PARADE. Susan Thompson was the wife of Simon Thompson and, at one point, the oldest woman at Tuscarora. In the late 1800s to early 1900s it was not custom to dress in traditional clothing. Only a few of the older Tuscaroras owned beaded clothing such as Simon and Susan Thompson and Alvin Hewitt. These outfits were typically worn for special occasions and events like parades and ceremonies. (Courtesy Jonathan family.)

REED BARK HOUSE, C. 1938. In this image are, from left to right, Myna Smith, her granddaughter Terry Mt. Pleasant, and Leona Reed in front of the popular Reed bark house. The Reed family on Mount Hope Road owned many entrepreneurial businesses such as a public shower house, lacrosse box, mobile home park, and the bark house replica. They sold native crafts and leather goods while giving tours of the bark house to the many tourists that visited the Tuscarora Nation. (Courtesy Claudia Reed.)

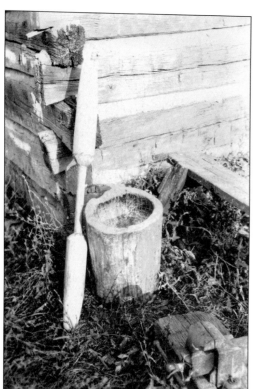

DAN SMITH'S CORN POUNDER, 1950. Tuscarora white flour corn is equipped with a thick hull that is dissolved by boiling the kernels in wood ashes. A Tuscarora home typically had a corn pounder to pound the white corn into flour for cooking. The corn pounder is used like a pestle and mortar, to grind the corn into fine flour that would be used to make corn bread and mush, or porridge. The pounding of corn can be heard on quiet days for long distances. (Courtesy National Philosophical Society.)

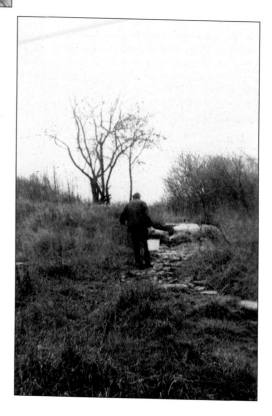

HAULING WATER FROM A SPRING. Indoor plumbing was not common until the 1960s. Wells and springs are still popular sources of drinking water at Tuscarora. Many seeps and springs can be found along the exposed bedrock of the Niagara Escarpment. William Greene is seen hauling a bucket of water from a well used spring along Upper Mountain Road. (Courtesy Suzanne Goater.)

THE ARMY CAMP ON TUSCARORA.
The "Army Camp" was a unit of the Niagara Area Defense System, housing soldiers of the 44th Anti-Aircraft Gun Battalion during the Cold War. The camp contained sleeping quarters, recreational facilities, and firing units, which consisted of anti-aircraft guns operated by remote control. The camp contained a large mess hall, which was used for dances and parties attended by many Tuscaroras. The base also held open house nights for Tuscaroras to visit the camp. Pictured at right is Elden Fischer (right) with an unidentified friend, both stationed at the base on Mount Hope Road. Below are, from left to right, James Baggis, Wendy Mt. Pleasant, Terry Mt. Pleasant, and two unidentified men visiting on open house night. (Right, courtesy Elden Fischer; below, courtesy Suzanne Goater.)

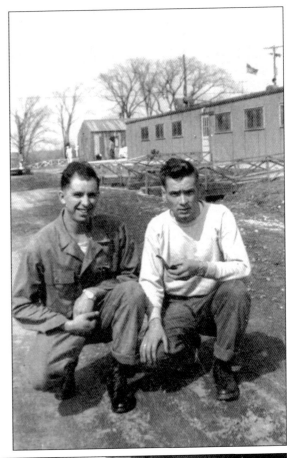

STAIRWAY TO GUEST CHAMBERS, 1895. The small log homes required small furniture, including portable stairways. This type of rough-hewn stairway was typical in the early 1800s and is a good example of this time period. They were carved from a single piece of wood and were usually only eight inches wide. (Courtesy Orrin Dunlop Collection.)

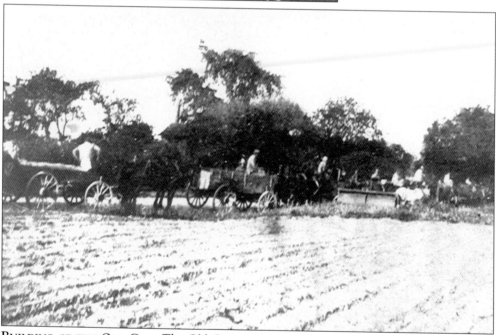

BUILDING OF THE OLD GYM. The Old Gym took two years to construct and was completed around 1920. Local lumber was cut and milled by Levi and Lyman Johnson. Titus Patterson, who was a member of the Tuscarora All-Star basketball team, led the effort to find a new home for basketball games at Tuscarora. (Courtesy Chief Kenneth Patterson.)

RAMBLIN' LOU. Entertainer Ramblin' Lou, who once lived at Reed's Trailer Park, performs here in the Old Gym on Mount Hope Road. He is a popular entertainer who currently has a local AM radio show. It is said that he delivered milk at Tuscarora when he was a young man for a local farm. (Courtesy Suzanne Goater.)

CLINTON RICKARD AND HIS WIFE BEULAH MT. PLEASANT. Clinton Rickard once described how Nelson and Margaret Mt. Pleasant, parents of Beulah, visited him to discuss their desire to have him as a son-in-law. They were married in 1931 and had seven children together. In 1973, Barbara Graymont, a noted anthropologist, chronicled his life in *Fighting Tuscarora: The Autobiography of Chief Clinton Rickard*. (Courtesy Niagara Falls Public Library.)

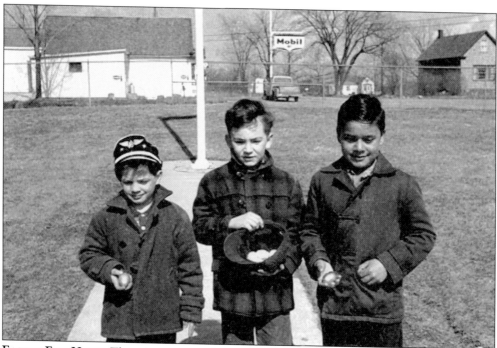

EASTER EGG HUNT. Three boys are standing across the road from the Red and White Store and filling station. The store was one of the first two gas stations. Later on, a restaurant was added, serving three meals a day. The store was started by Emmett Hill, the father of Johnny Hill. The store was operated by William "Jug" Farnham for 20 years. (Courtesy Tuscarora Indian School.)

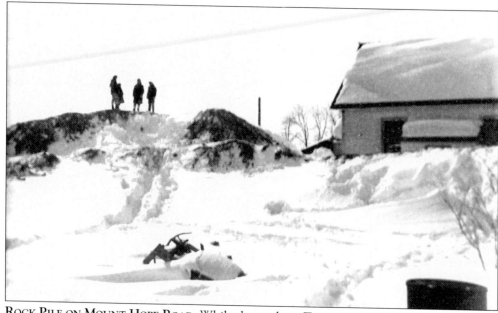

ROCK PILE ON MOUNT HOPE ROAD. While the roads on Tuscarora were being paved, the state piled stones on Mount Hope Road, near the site of the Old Gym. It was very popular for people of all ages to climb the rock pile. In this photograph, one can see that Tuscaroras would still climb it in the dead of winter. (Courtesy Suzanne Goater.)

Five

SUSTENANCE
AND ECONOMICS

TUSCARORAS IN NORTH CAROLINA. Fish and shellfish were a significant food source for Tuscaroras in what is now the Carolinas. Chief Elton Greene said, "In the old days, before our people came northward from North Carolina, they would get into their canoes and paddle down the creeks and rivers to the sounds, to gather food and to fish." "Tuscaroraw" is shown on this map on the Roanoke River, near the site of a reservation set aside for Tuscarora people at the end of the Tuscarora War. (Courtesy Tuscarora Environment Office.)

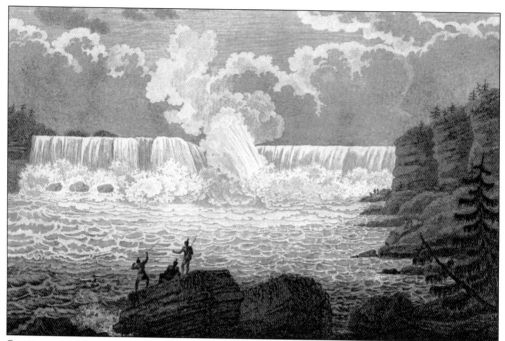

SPEARING AT NIAGARA RIVER. Evidence of fishing culture predating the Tuscarora arrival along the Niagara River can be found in many archeological sites. Permanent Tuscarora residency along the river revitalized the Haudenosaunee occupation of ancient fishing sites. This print is called *View of the Horseshoe Fall of Niagara* from the *Travels through the States of North America.* (Courtesy Niagara Falls Public Library.)

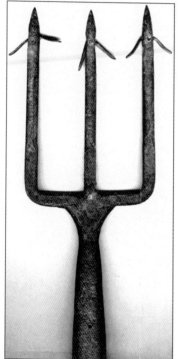

FLYBEARD SPEAR, C. 1955. The fabrication of spears was a common practice among Tuscarora men working in the factories of Niagara Falls. A most unique spear used for taking Niagara River sturgeon was the flybeard, a large and heavy spear with hinged barbs. The handles of flybeard spears were often tethered to the fisherman or the shore with a long rope. (Courtesy Fillmore Rickard.)

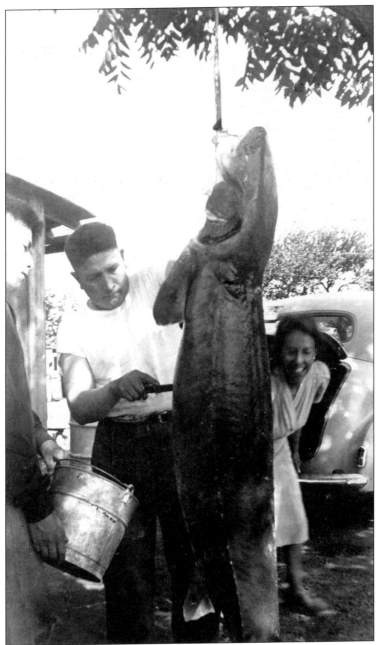

LOWER NIAGARA RIVER, 1945. River fishing was a dangerous undertaking. The powerful currents and instantaneous whirlpools of the lower Niagara made spearing fish difficult. The Tuscaroras utilized the old practice of creating fishing docks or small piers to steer fish towards shore within reach of their long river spears. The downstream sides of the docks, or pockets, were lined with red or gray shale depending on the desired catch. Almost all of the spearing was done at night with kerosene lanterns. Sturgeon, blue pike, walleye, perch, and suckers were principal targets. Seen here are, from left to right, Ellwood Jacobs Sr., Duke Jacobs Jr., and Ellen Jacobs, tending to their freshly caught sturgeon on the lower Niagara River. (Courtesy Eugene and Elva Greene.)

A CATCH FROM GILL CREEK, C. 1948.
James (left) and older brother Peter
Bissell stand with their catch from Jesses
Creek, now called Gill Creek. There were
two types of fishing in those days, creek
fishing and river fishing. Creek fishing
at Tuscarora was mostly limited to Gill
Creek and Cayuga Creek. Fish were often
stalked during the spring with spears,
and later, guns. The concussion of the
blast from a shotgun or rifle either killed
the fish or stunned it enough for capture.
(Courtesy James and Wendy Bissell.)

VIEW OF LOWER RIVER. Almost all of the river fishing took place in a stretch of the lower river
from Devils Hole to Lewiston. Sturgeon and blue pike were principal targets for fisherman, who
often sold their catch at local market. Popular docks included the Dashers, the Boilers, the Point
Dock, and the Sturgeon Hole. One dock, Belan's Hole, was named after Jonas "Belan" Greene.
He was noted for his lengthy occupation of his dock, since unoccupied docks were generally
considered open for the taking. (Courtesy New York Power Authority Archives.)

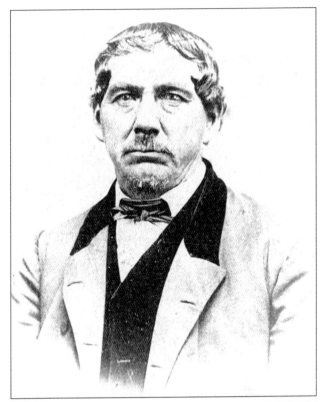

CHIEF JOHN MT. PLEASANT, C. 1886. Orasmus Turner, Holland Land Company Surveyor, interviewed Tuscarora chief John Mt. Pleasant in 1851, in *History of the Holland Land Purchase*: "I used to catch salmon in Eighteen Mile Creek with my bare hands." Introduction of pacific salmon and trout by American and Canadian resource agencies replaced the native Atlantic salmon. (Courtesy Orrin Dunlop Collection.)

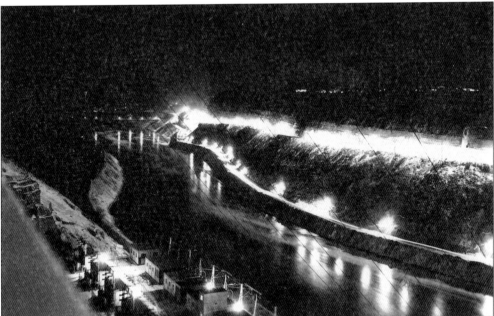

NIAGARA CONSTRUCTION AT NIGHT. Several changes along the Niagara affected Tuscarora fishing. The construction of the Niagara Power Project destroyed the Dashers, a popular fishing dock area. Pollution and over-fishing changed the fish and fishing practices during the 20th century. (Courtesy New York Power Authority Archives.)

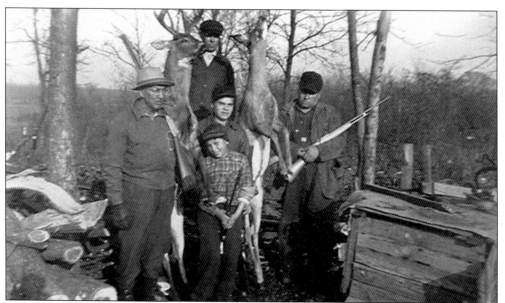

THE HEWITT MEN AND THEIR GAME. Seen here are, from left to right, (first row) Franklin Hewitt; (second row) Silas Hewitt Sr., Everett Hewitt, and Silas Hewitt Jr.; (third row) an unidentified man. The art of hunting was a staple to the life of Tuscarora men. It is said the first deer was shot on Tuscarora in 1936. Before this time, the typical game was water fowl, rabbit, and turkey. (Courtesy Susan Patterson.)

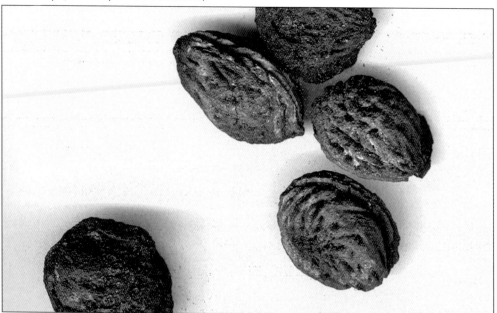

PEACH PITS FROM FORT NEYUHERÚKE, 1712. Tuscarora farmers are noted for fruit production. Tuscarora people fled the Carolinas with fruit seeds and stock. The Tuscarora missionary Gideon Hawley noted that Tuscarora communities in Broome County, New York, were depressed due to a severe winter, which killed pear trees that were "laboriously" brought from the south. During an archeological dig, these peach pits were unearthed at the Tuscarora fort in North Carolina. (Courtesy Chief Kenneth Patterson.)

TRADITIONAL GARDENING. Farming has always been a part of life for Haudenosaunee people. A creation story recorded by Tuscarora ethnologist John Napoleon Brinton Hewitt in 1890 states that the Creator provided gifts of corn, beans, squash, potatoes, strawberries, and tobacco. This photograph from the 1930s shows one of the many cornfields at Tuscarora. (Courtesy Susan Patterson.)

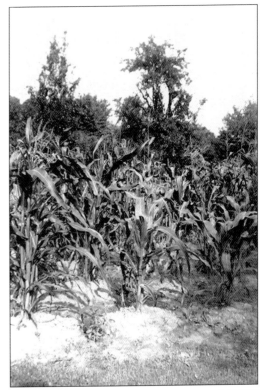

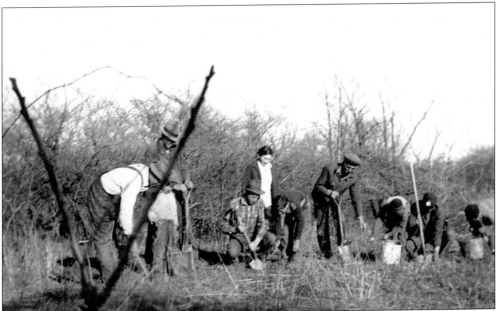

4-H CLUB. Planting trees for the 4-H Club was serious business at Tuscarora. Members and their families would all take part in the forestry activities, making it an all-ages event. Planting pine trees here are, from left to right, Harry Patterson, Donald Patterson, David Patterson, Titus Patterson, Ruthie Patterson, Kenny Patterson, William Greene, Leander Patterson, Franklin Patterson, and David Patterson. (Courtesy Chief Kenneth Patterson and family.)

TUSCARORA WHITE FLOUR CORN. Most notable among the food crops at Tuscarora is the flour corn. Tuscarora white corn is an exceptionally large type of corn that is dried in the fields and stored in hanging braids. Husking bees are social events for people to help harvest, husk, and braid the corn. Harvest takes place in the fall, or when "the great bear chase is on," referring to the heightened big dipper constellation luminance in the northern sky. The dried corn is boiled in wood ashes before cooking because of the thick hull. Many people still come to Tuscarora for their corn. The left photograph above shows the braids of corn hanging in a barn, and below, Norton Rickard displays three large cobs of white corn. (Left, courtesy Neil Patterson Jr.; below, courtesy Norton Rickard.)

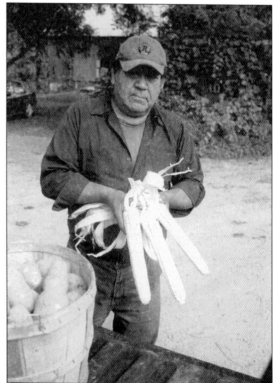

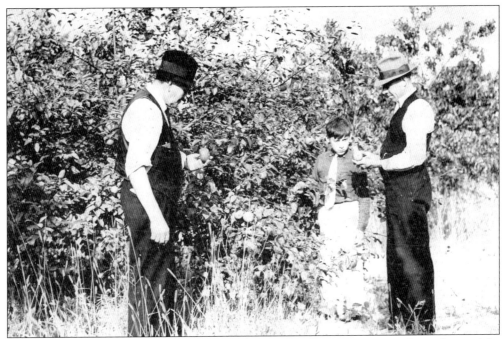

APPLE TREES. Tuscarora settlement along the Niagara Escarpment was also influenced by upland environments. Nestled between Lakes Erie and Ontario, northern Niagara County is often described as a Carolinian climate. Fruit and nut trees thrive in the long growing season along the escarpment. The area receives on average only 10 percent of the annual snowfall that Buffalo receives 30 miles away. From left to right are, Frank Williams, Kenneth Patterson, and Chief Harry Patterson. (Courtesy Chief Kenneth Patterson and family.)

CHIEF WILLIAM CHEW'S FARM. Chief William Chew's farm on Chew Road provided produce and milk to the Tuscarora community during times of need. A typical Tuscarora family would tend to a small vegetable garden and some farm animals, but few owned extensive farms like Chief Chew, Chief William Mt. Pleasant, Clinton Rickard, Titus Patterson, and others. (Courtesy Tuscarora Environment Office.)

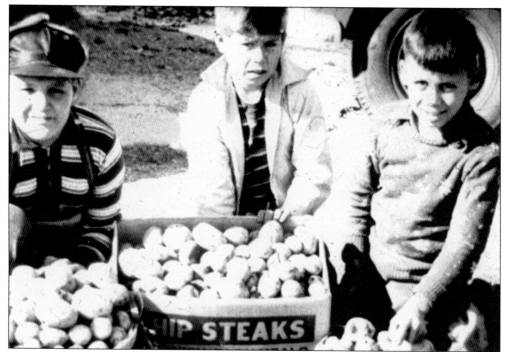

PRODUCE FROM TUSCARORA FARMS. Tuscarora farmers are noted for fruit production and varieties. The shallow soils of the escarpment were ideal for vineyards and orchards. According to the New York State Indian Census of 1890, there were 269 acres of orchards at Tuscarora and "not a ragged, untrimmed orchard on the reservation." Sitting by the fruits of their labor are, from left to right, two unidentified children and Francis Henry. (Courtesy Tuscarora Indian School.)

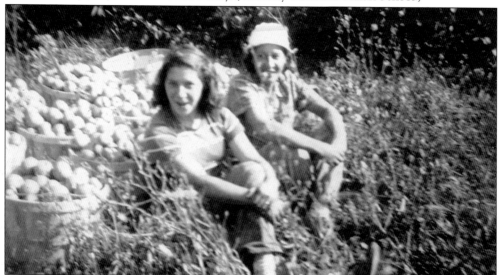

ON THE NICHOLS FARM. Many young people, like Adelaide Printup-Davis (left) and Birdie Crogan, grew up picking fruit from orchards on and off the reservation. "The truck would come around and pick us up in the morning. Twenty dollars per day. Good spending money," said Printup-Davis who picked fruit on the Erwin Nichols Farm, north of the Tuscarora Nation. (Courtesy Cameron Nichols family.)

PICKING GRAPES. The memory of grapes from their southern home prompted Tuscarora farmers to send a party to bring back grape stock, peach pits, and apple seeds to their home at Niagara. The oldest grape vineyard in Niagara County was located at Tuscarora, mainly because the soil at Niagara was especially suited for growing grapes, and Tuscarora utilized this advantage. Samuel Kirkland, Tuscarora missionary while in Oneida territory, cautioned Tuscaroras about making wine from the scuppernong grape variety brought back from Carolina. Tuscarora farmers have never sold their grapes for wine making. Dr. Earl Bates reported, "Their grapes are now Concord and Worden." Below is an aerial view of the Patterson farm on Moyer Road in the 1950s. The extensive orchards and grape vineyards can be seen. (Above, courtesy Chief Kenneth Patterson and family; below, courtesy Tuscarora Environment Office.)

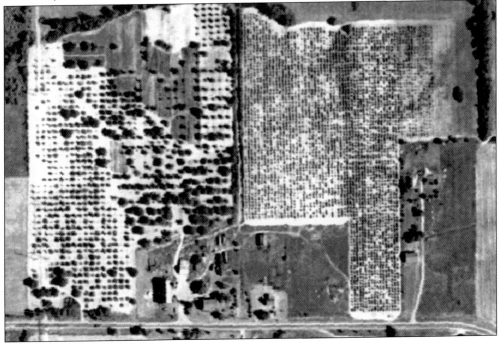

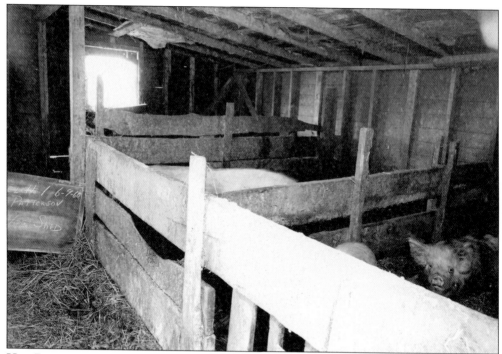

HOG BARN ON PATTERSON FARM. Eventually the local demand for milk across the region turned Tuscarora fruit farmers into dairymen. In 1890, there were 3,007 bushels of wheat, 3,853 bushels of oats, and 2,625 bushels of corn. There were 121 horses, 220 pigs, 1,743 chickens, and 173 cattle. This 1960 photograph shows the hogs in their stalls on the Patterson farm before it was demolished for the construction of the Lewiston Reservoir. (Courtesy New York Power Authority Archives.)

TUSCARORA AT CORNELL UNIVERSITY. Dr. Earl Bates, Cornell University, reported a local phenomena described by the Tuscarora as the "Fruit Fever" in 1924 and again in 1959. New health standards for milk production shifted efforts from cows to fruit, resulting in over $4,000 in revenue from Tuscarora orchards. Standing on the Cornell campus are, from left to right, Noah Henry, Franklin Doctor, Alcena Doctor, and Dr. Bates. (Courtesy Susan Patterson.)

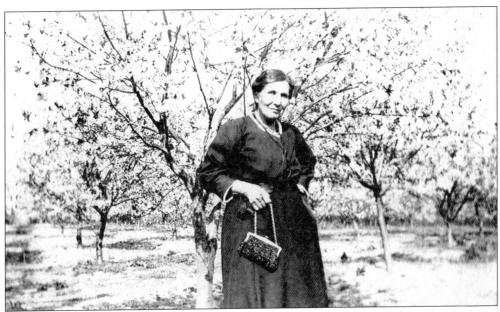

MOUNT HOPE ROAD ORCHARDS. Tuscarora farmers were very successful in growing pears and peaches, which brought a premium price in the Buffalo and Niagara Falls markets. Several Tuscaroras wanted to erect a marker to the Idaho pear variety in an old orchard near the Brant Mission site, between Lewiston and Niagara Falls in 1950. Lecturers on the Niagara Gorge bus tours claim that "nearly every fruit that grew in the Garden of Eden originated in the Niagara Frontier." In this photograph, Rachel Mt. Pleasant stands in her family's orchard around 1896. (Courtesy Orrin Dunlop Collection.)

MILDRED GARLOW AND HER DOLLS. Mildred Garlow was the last Seneca landowner living at Tuscarora. She was from the Deer Clan and lived on Garlow Road. Garlow was known for her doll making. It was common to find her, along with her mother, at Prospect Park selling her dolls. These dolls became known as Garlow dolls, because they were completely her design. (Courtesy Patrick Simon and family.)

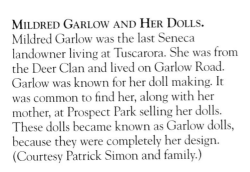

75

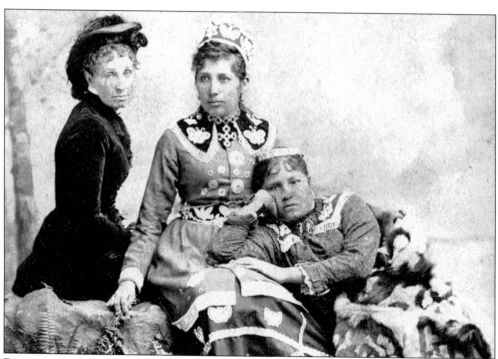

BEADWORK OF THE 19TH CENTURY. The richly beaded clothing of collars, belts, leggings, skirts, and crowns reflect the Victorian aesthetics of the late 19th century. The young lady in the middle is wearing multiple pieces of Iroquois silver work, including the 10 broaches on her shirt, the silver cross between her collar, and the delicate choker. (Courtesy Lulu Benedict collection.)

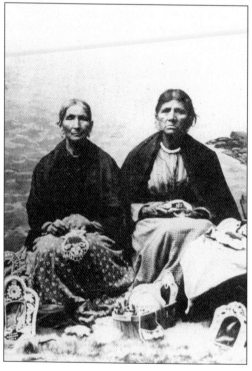

TUSCARORA SILVERWORK AND BEADWORK. Posing with their beadwork are Delia Patterson (left) and Elizabeth Patterson, daughters of Harry and Abigail Patterson. The beautiful beadwork pieces on display at their feet are common souvenirs bought by tourists to Niagara Falls. Tuscarora women continue to make picture frames, pincushions, jewelry holders, wall hangings, and small purses adorned with flowers, birds, animals, and place names. (Courtesy Norton Rickard and family.)

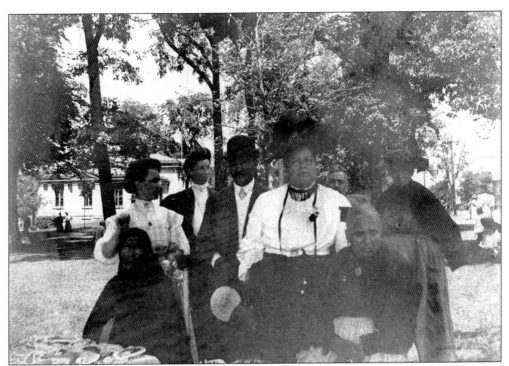

TUSCARORA WOMEN SELLING BEADWORK. In May 1936, Niagara State Reservation Police were instructed to bar Tuscarora women from selling beadwork and leather goods at Prospect Park. Ever since the establishment of the Niagara State Reservation in 1885, Tuscarora women have been selling their goods in the park. A month later in June, after the women complained to Albany, their privileges were restored but permits were now to be issued and no newcomers were to be given permits. Today only a handful of permits are issued to Haudenosaunee vendors through a lottery, and the number of restrictions and rules associated with the permits make it hard to enjoy the tradition that has been in place for more than 120 years. Above, in this photograph from around 1900, tourists have their picture taken with Tuscarora vendors. Below is a stereograph of a Tuscarora woman and her child selling their beadwork at Prospect Park. (Above, courtesy Lulu Benedict collection; below, courtesy Niagara Falls Public Library.)

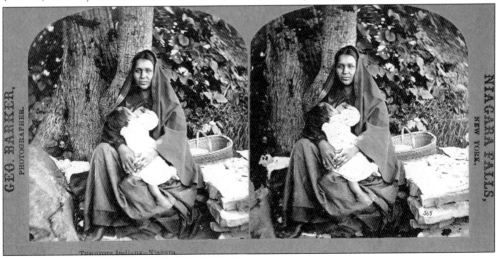

HARRY PATTERSON'S FARM. Chief Harry Patterson, Bear Clan, owned a large farm on Moyer Road. The farm was once the homestead to John and Caroline Mt. Pleasant. His farm was a source of income to many people. He would pay farmhands to harvest his wheat, hire kids to pick fruit, and provide a small source of income to those willing to work on his farm. Chief Patterson and his sons are recorded at the New York State College of Agriculture as Niagara County's leading grain producer in the 1950s. Both photographs show the expansive labor and machinery his farm utilized to harvest his hundreds of acres of farmland. (Courtesy Susan Patterson.)

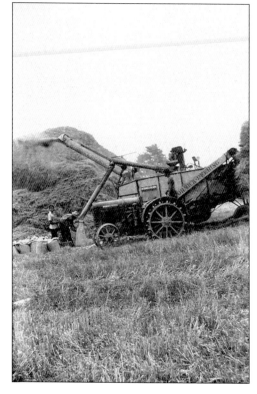

Six

Education of Mind and Spirit

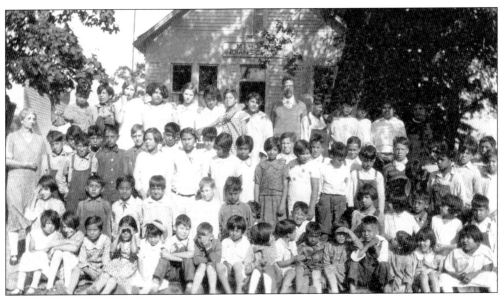

Students at School. Tuscarora was typically divided into two sides, with a school provided to each half. Children on the east side would attend school No. 01 on Mount Hope Road, while students on the west side attended school No. 02 on Green Road. Students gather here in front of the Mount Hope Indian School. Some of the students in the photograph are sisters Sarah and Lucy Chew, brothers Nick and Donald Patterson, and Patricia Patterson. (Courtesy Patricia Wegerski.)

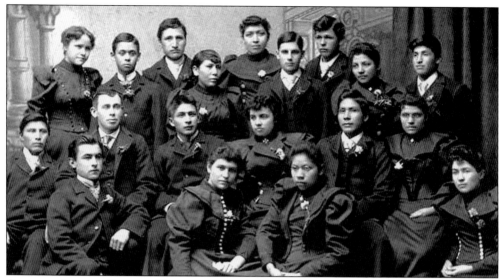

CARLISLE INDIAN SCHOOL GRADUATION, 1894. Howard Gansworth, Wolf Clan, is in the third row, second student from the left. He is one of the many children from Tuscarora sent to the Carlisle Industrial (Indian) School in Pennsylvania for a new education. These Tuscarora children joined other Native Americans from across the United States and were forced to dress in modern clothing and forbidden to speak their native languages. (Courtesy Tuscarora Environment Office.)

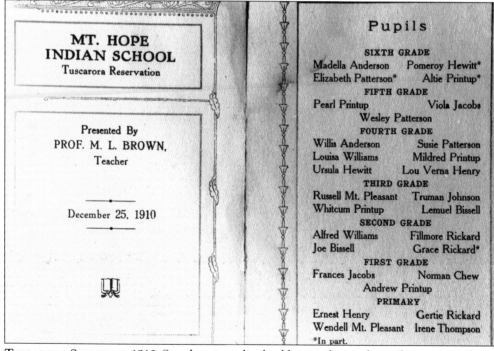

MT. HOPE
INDIAN SCHOOL
Tuscarora Reservation

Presented By
PROF. M. L. BROWN,
Teacher

December 25, 1910

Pupils

SIXTH GRADE
Madella Anderson Pomeroy Hewitt*
Elizabeth Patterson* Altie Printup*

FIFTH GRADE
Pearl Printup Viola Jacobs
Wesley Patterson

FOURTH GRADE
Willis Anderson Susie Patterson
Louisa Williams Mildred Printup
Ursula Hewitt Lou Verna Henry

THIRD GRADE
Russell Mt. Pleasant Truman Johnson
Whitcum Printup Lemuel Bissell

SECOND GRADE
Alfred Williams Fillmore Rickard
Joe Bissell Grace Rickard*

FIRST GRADE
Frances Jacobs Norman Chew
Andrew Printup

PRIMARY
Ernest Henry Gertie Rickard
Wendell Mt. Pleasant Irene Thompson
*In part.

TUSCARORA STUDENTS, 1910. Seen here is a school publication listing the students in attendance at the Mount Hope Indian School. Children could not always take their studies seriously, because of the many family obligations that young ones had to make ends meet. It was common to see only two to three students in class at a time. (Courtesy Chief Kenneth Patterson.)

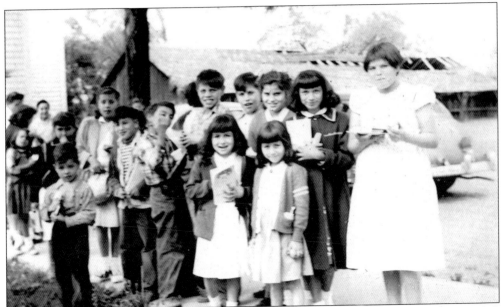

STUDENTS AT THE TUSCARORA BAPTIST CHURCH, C. 1945. Seen in this image are, from left to right, (first row) Corky Bomberry; (second row) Barbara Hill, Elaine Rice, Turhan Clause, unidentified, Lili Rae Wilson, and Elizabeth Hill; (third row) Cyril Printup, Ruben Jacobs, Dorothy Printup, Tonilee Seneca, and Sunnylee Printup. The horse barn behind the students is used to hold the congregation's horses and buggies which they rode to church. (Courtesy Tuscarora Environment Office.)

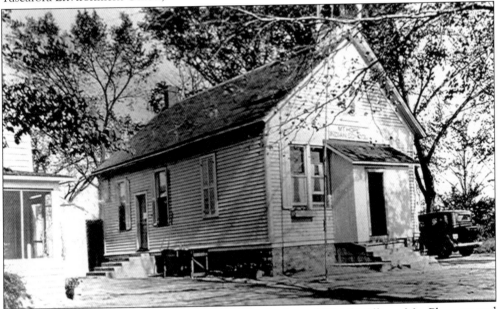

MOUNT HOPE INDIAN SCHOOL. Under the leadership of Chief William Mt. Pleasant and through the planning of Miss Thayer, a new school was built by 1851. The 18-by-24-foot school was well furnished with two stoves and a large woodpile already prepared. On January 14, 1851, Miss Thayer commenced her first day, having 40 students in attendance. (Courtesy Tuscarora Indian School.)

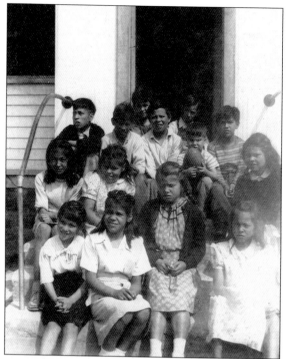

TUSCARORA STUDENTS. Seen here are, from left to right, (first row) Marlene Jacobs, Beverly Chew, Judith Printup, and Violet John; (second row) Sonja Maracle, Diane Printup, and Carol Pembleton; (third row) Joseph Jacobs, Conrad Pembleton, Phillip Jacobs, Walter Printup with football, and Fred Davis; (fourth row) Ronald Mt. Pleasant and John Gansworth. (Courtesy Tuscarora Environment Office.)

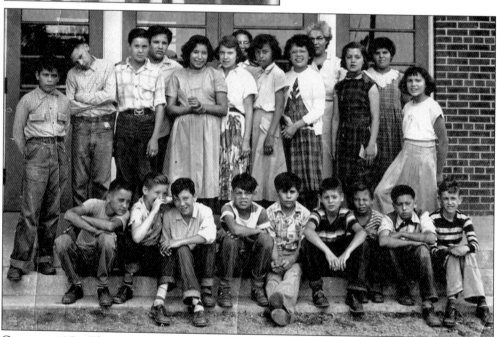

CLASS OF 1954. The first graduating class at the new Tuscarora Indian School are, from left to right, (first row) Alfred Bissell, Crandall Johnson, Alfred Williams, Cyril Printup, Ruben Moses, William Anderson, Jesse Moses, Wayne Gansworth, and Charles Hinman; (second row) William Higdon, Harold Bissell, Tracy Johnson Jr., Harry Jacobs, Patricia Jack, Louise Mt. Pleasant, Clara Mt. Pleasant, Carol Moses, Kay Pembleton, teacher Dorothy Crouse, Martha Mt. Pleasant, Sunnylee Printup, and Patricia Mt. Pleasant. (Courtesy Tuscarora Indian School.)

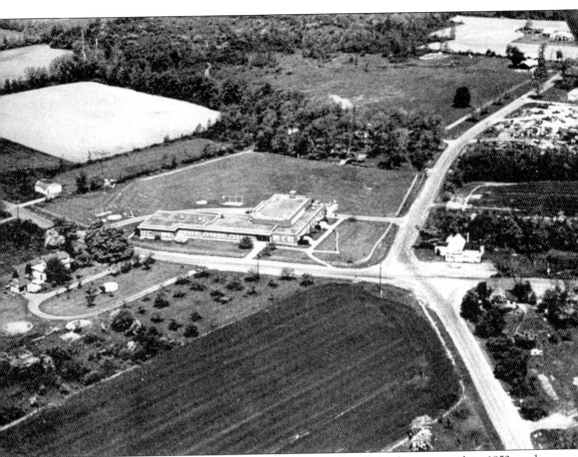

THE TUSCARORA INDIAN SCHOOL. The Tuscarora Indian School was started in 1952, and students began occupying it in 1953. It was completed in 1954. Initially the school was referred to as the Tuscarora Central School, but eventually Central was dropped and Indian was added. In 1974 and 1975, an additional six classrooms were added. The renovation of the basement made room for a new clinic and dentist office, rooms for the reading program, and an Affirmative Action office. Other renovations included a library media center, a larger gymnasium that doubles as an auditorium, and a kitchen and cafeteria that now serves breakfast and lunch daily. (Courtesy Tuscarora Indian School.)

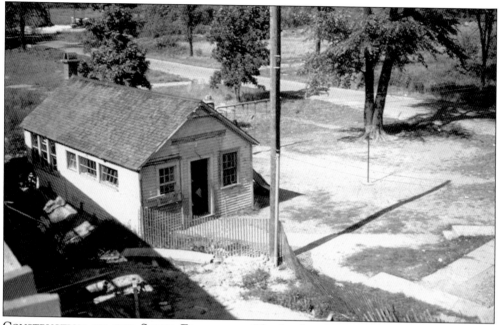

CONSTRUCTION OF THE STATE EDUCATION. The kindergarten and first grade classroom, known as the Littleroom, was still erect while the construction of the new Tuscarora Indian School was built in 1952. The new school, shadowing the old schoolhouse, was built where both schoolhouses, the clinic room, and the living quarters for the principal once stood. (Courtesy Tuscarora Indian School.)

CLASS PICTURE, C. 1955. Seen in this photograph are, from left to right, (first row) Judy Flynn, Reva Williams, Dale Johnson, Randy ?, Linda Jacobs, and Jean Flynn; (second row) Dennis Printup, Priscilla Patterson, Elaine ?, Judy Printup, Nora Jacobs, James Bissell, and Martin Johnson Jr.; (third row) an unidentified teacher, Lewis Garlow, Ellis Printup, Kenny Rickard, David Bissell, Franklin Patterson Jr., and Sandy Maracle. (Courtesy Tuscarora Environment Office.)

GRADUATION DAY, 1951. Seen here are, from left to right, Ann Ruth Mt. Pleasant, Jean Smith, Florence Rickard, Donna Woodbury, and Frieda Williams. The Tuscarora Baptist Church honors the Tuscarora graduates with a commencement ceremony every year. In this photograph, they are wearing the same dresses and boutonnieres. The girls were part of a singing group and girls' basketball team. (Courtesy Tuscarora Indian School.)

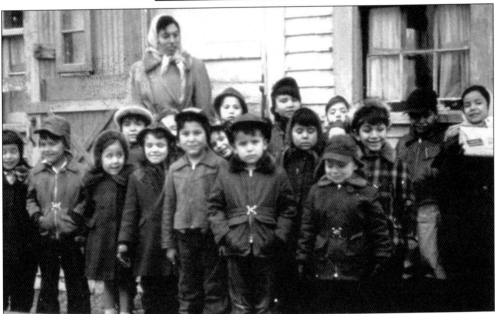

FIRST GRADE CLASS, 1953. The students, standing in front of the Littleroom on Walmore Road are, from left to right, (first row) two unidentified, Roslyn Hewitt, ? Rickard, William Patterson, Neil Gansworth, and unidentified; (second row) Lille Rae Wilson, two unidentified, ? Billings, and Walter Zomont; (third row) teacher Miss. Pastore, Lana Johnson, Arnold Rickard, Martha Mt. Pleasant, unidentified, and Linda Clara Wilson. (Courtesy Tuscarora Indian School.)

TUSCARORA INDIAN SCHOOL LANDSCAPE, 1961. The planting of hickory trees (left) is seen in front of the school on Mount Hope Road. One of the two trees is still standing 45 years later, now along the Tuscarora Indian School Garden and Nature Trail, which was added in 2001. The ribbon cutting of the trail was honored with a pine tree planting by Chief Jake Swamp (below) at the beginning of the trail. The three-quarter-mile trail starts on the east side of the school and connects to the Picnic Grove, with native flowers and plants found along the way. (Left, courtesy Tuscarora Indian School; below, courtesy Tuscarora Environment Office.)

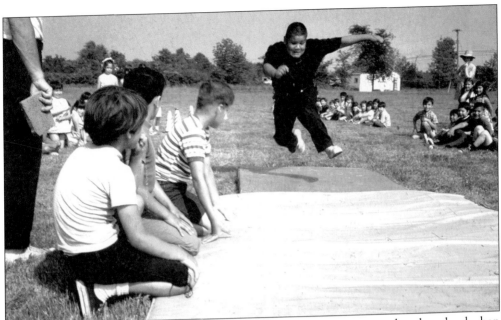

TUSCARORA INDIAN SCHOOL PLAY DAY. The tradition of Play Day started at the school when it was built in 1956. Play Day was held during the last week of classes and was a series of athletic events such as kick the stick, high jump, and 50-yard dash. In this 1971 photograph, Sherman Green Jr. participates in the long jump while Steven Dubuc and Michael Printup look on. (Courtesy Tuscarora Indian School.)

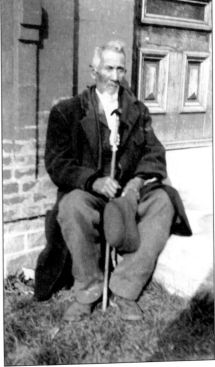

PASTOR SAMUEL JACOBS. Samuel Jacobs was born about 1814 in Oneida and married Betsy Thompson, an Onondaga from Tuscarora. He was the pastor for the Tuscarora Presbyterian Church after Rev. Charles Keeler left his post in 1863. Other members of his congregation included Chief John Mt. Pleasant and Chief Elias Johnson. Jacobs continued to preach until his death in September 1889. (Courtesy Orrin Dunlop Collection.)

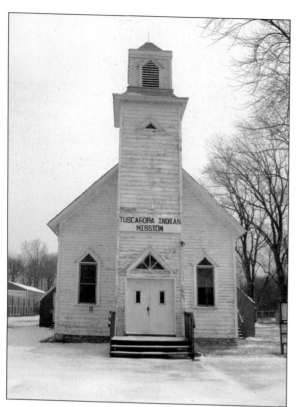

TUSCARORA PRESBYTERIAN CHURCH. Rev. Elkanah Holmes, the first missionary from the New York Missionary Society, began the first Christian church at Tuscarora in 1805. His members included Chief Sekwari:θre and his wife; Nicholas Cusick, an interpreter, and his wife; and Apollas Jacobs and Mary Pembleton. The church, now known as the Tuscarora Indian Mission, is located on Walmore Road. (Courtesy J. Moor.)

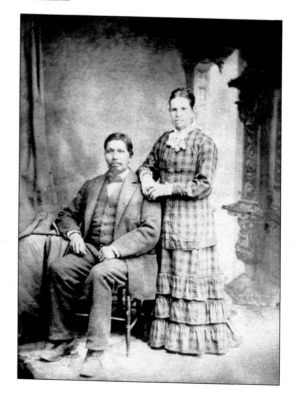

ISAAC AND CATHERINE JACK, 1880. Isaac N. Jack, Turtle Clan, was a part of the Tuscarora Temperance Society in the late 1800s. He was clerk when the Tuscarora Baptist Church was reorganized in March 1860. It was organized at the home of James Johnson, with Rev. James Cusick as moderator. (Courtesy Tuscarora Temperance Society.)

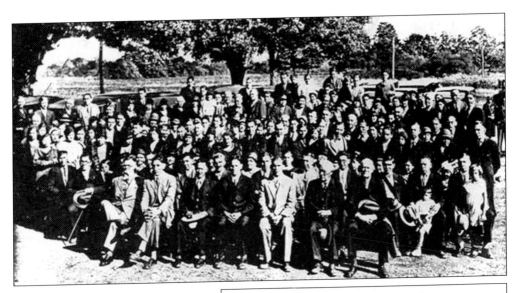

TEMPERANCE LEAGUE, 1932. On February 19, 1830, the Tuscarora formed a temperance society with the chief founders being William and John Mt. Pleasant. Two years later in March, a general Iroquois temperance league was formed at Cattaraugus to embrace all the Seneca reservations. In 1833, the Tuscarora Temperance Society reorganized to join the Six Nations Temperance League, which included a coronet band and singing in the different Haudenosaunee languages. The One Hundred Years' Celebration of the Iroquois Temperance League happened (seen in the photograph above) in October 1932. The celebration included addresses by Dr. Earl Bates, Cornell University; Hon. Edmund Cooke, United States Congress; Hon. Henry Scattergood, United States Bureau of Indian Affairs; and Clinton Pierce, Onondaga Nation. The program (seen in the photograph below) indicates that Noah Henry and Joseph Woodbury were part of the general committee to the Celebration. (Above, courtesy Tuscarora Environment Office; right, courtesy Tuscarora Temperance Society.)

```
1832————————1932
GRAND LODGE
SIX NATIONS TEMPERANCE LEAGUE
ONE HUNDRED YEARS' CELEBRATION

Cattaraugus Reservation
October 3–8, 1932
———
Officers
President,Franklin P.Doctor,Tonowanda
Vice Pres.,Le Roy Snow, Cattaraugus
Secretary,Mrs.Simpson Rickard,Tuscarora
Treasurer,Charles Conklin, Cattaraugus
Chaplain, Alton Green, Tuscarora

General Committee

Albert Shenandoah, chairman,  Onondaga
Charles Steeprock, secretary, Onondaga
Theodore Gordon              Cattaraugus
King Nephew                  Cattaraugus
Cornelius Seneca             Cattaraugus
Yankee Spring                 Tonowanda
Raymond Moses                 Tonowanda
Arthur Hoag                    Allegany
Clinton John                   Allegany
Noah Henry                    Tuscarora
Joseph Woodbury               Tuscarora
Milton Babcock                 Onondaga
```

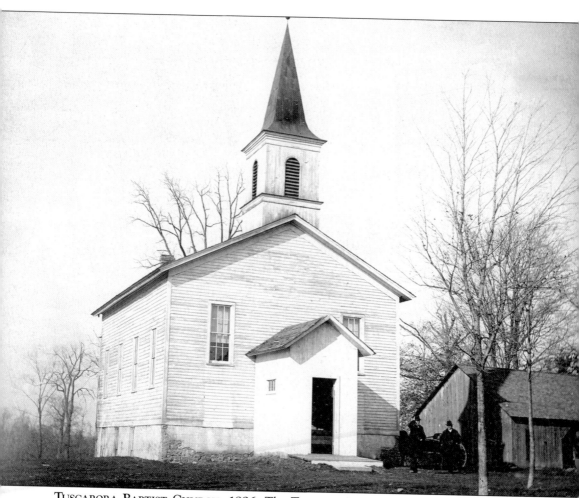

TUSCARORA BAPTIST CHURCH, 1896. The Tuscarora Baptist Church was organized first in 1836 by Rev. James Cusick, who became the first pastor. It was erected on the Tuscarora Nation Farm, north of Upper Mountain Road. A few years later, it was accidentally burned down, and a new smaller building was built closer to the road. The Kansas Movement of 1846 deteriorated the congregation, and eventually the building was sold to the Tuscarora Nation, where it stood empty and forsaken. The year 1860 saw the revival of the church with Reverend Cusick and six other members, and in February 1862, the new church was dedicated, being the third Baptist church built on the Tuscarora Nation. (Courtesy Orrin Dunlop Collection.)

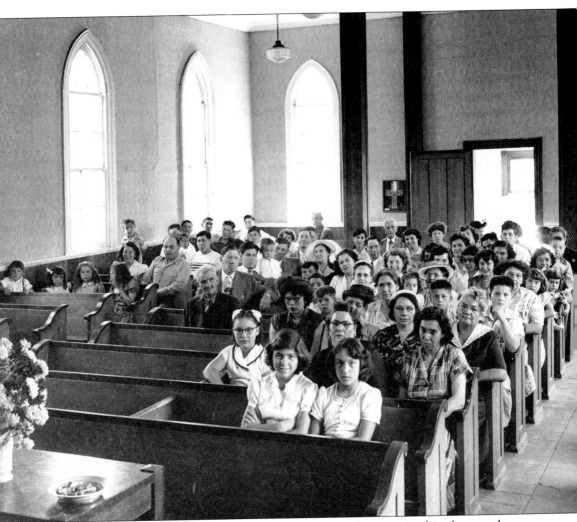

INSIDE TUSCARORA BAPTIST CHURCH. Most of the men and women in this photograph are sitting apart, wives on the right and husbands on the left. This may be an old church tradition or a vestige of the longhouse practice of division seating among the sexes. Today the church is presided over by Pastor Walter Printup Jr. and is located on Mount Hope Road. (Courtesy Chief Kenneth Patterson and family.)

HOLY FAMILY CHAPEL. The first Catholic church at Tuscarora was built out of a former barn on Upper Mountain Road. In 1952, the Rev. Robert Arway arranged to lease William Mt. Pleasant's barn where members of the congregation, who were previously meeting in private homes for mass, built the church. A contractor in Niagara Falls donated a cement floor for the basement, which was previously used for animal stalls. Today the Catholic chapel is located on Chew Road. In the photograph below, members of the church gather by the painting of Mary, Joseph, and the Christ Child, in Native American attire. Pictured are, from left to right, Thomas Reed, Rev. James Plastaras, Jerry Willet, and Laurence Williams. (Courtesy Tuscarora Environment Office.)

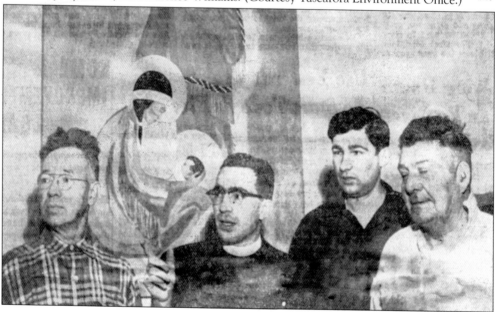

Seven

RELATIONS OUTSIDE THE BORDERS

TUSCARORA BAND PLAYERS. Pictured are, from left to right, Albert Printup, Nathanial Thompson, Ralph Greene, Luther Jack, Elton Greene, and Porter Printup. The Indian Band from Tuscarora played all over the world. At the inauguration of the Niagara Reservation State Park in 1885, an Indian band played at Goat Island and Prospect Park. (Courtesy Karen Kneeppel.)

TUSCARORAS WITH AMERICAN AIRLINES. To commemorate the arrival of American Airlines to Niagara Falls, the Tuscaroras were invited to take an inaugural flight. Standing in front of the American Airlines Flagship are, from left to right, Chief William Chew, Chief Jonathan Printup, Chief Eleazer Printup, Chief Thomas Isaac, George Nash, two American Airlines representatives, Noah Henry, Louise Henry, and three members of the 4-H Club. (Courtesy Neil Patterson Jr.)

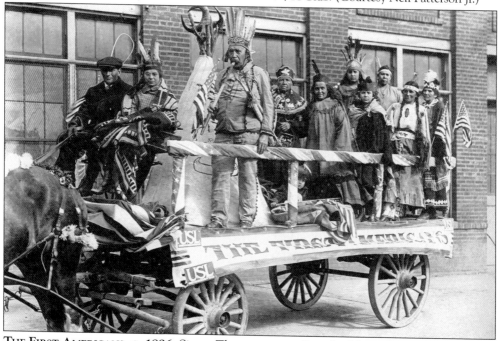

THE FIRST AMERICANS, C. 1896. Simon Thompson, standing third from the left with the flute, and his wife Susan Thompson, fourth from the left in the beaded crown, are participating in one of many local parades. Also on the float is Rachel Mt. Pleasant, far right. (Courtesy Orrin Dunlop Collection.)

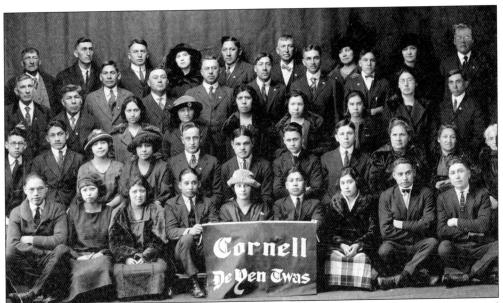

DE YEN TWAS AT CORNELL UNIVERSITY. This photograph of the Six Nations Agricultural Society includes many Tuscarora farmers. The organization met yearly at Cornell University because of the early participation of Dr. Earl Bates, an ethnologist at Cornell. One of the founding members was William Rickard. (Courtesy Chief Kenneth Patterson.)

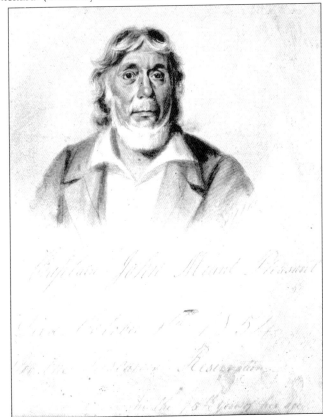

PORTRAIT OF CAPTAIN MT. PLEASANT. John Mt. Pleasant, Turtle Clan, was born in 1779 and the son of Margaret Jack. He was an officer in the British Army during the War of 1812 and took part in the battle of Queenston Heights. He acted also as an interpreter, being one who could speak languages of the different nations. (Courtesy Niagara Falls Public Library.)

THE HEWITT FAMILY. Seen here from left to right are Alvis D. Hewitt Sr., Silas Hewitt Jr., his son Alvis D. Hewitt, and Silas M. Hewitt Sr. Alvis Sr., brother to Smithsonian ethnologist John Napoleon Brinton Hewitt, was the last survivor of 285 Iroquois who fought for the Union in the Civil War. He was 95 years old when he passed away in 1937. His son Silas Sr. was a World War I veteran. (Courtesy Susan Patterson.)

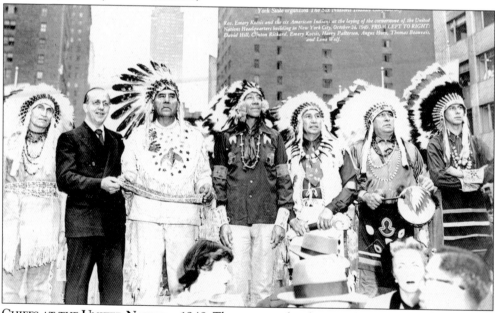

CHIEFS AT THE UNITED NATIONS, 1949. The quote on the photograph states, "American Indians Welcome at the United Nations. Did you know that the first United Nations was organized over 400 years ago when the American Indians in New York State organized the Six Nations Indian Confederacy." Two Tuscarora chiefs were present for the cornerstone ceremony for the United Nations Headquarters in New York City, Clinton Rickard (third from the left) and Harry Patterson (fourth from the left). (Courtesy Chief Stuart Patterson and family.)

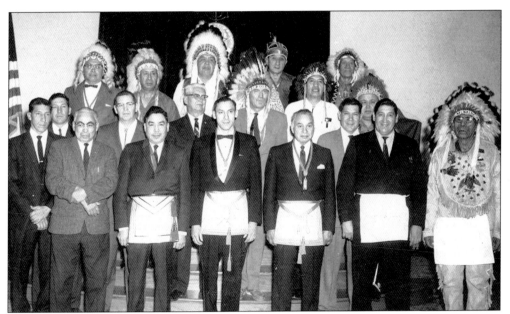

RANSOMVILLE MASONIC LODGE. Tuscaroras were often members of the Masonic Lodge. The Masonic Lodge held Indian Day once a year to celebrate their relationship with Tuscarora. Pictured here are, from left to right, (first row) Leander Patterson, Russell Blue-Eye, Edmund Jamison, Kenneth Patterson, unidentified, Franklin Patterson, and Clinton Rickard; (second row) Donald Patterson, unidentified, Raymond Moses, unidentified, Chet Bomberry, David Patterson, and Edison Patterson II; (third row) four unidentified persons and Harry Patterson. (Courtesy Susan Patterson.)

TO THE UNITED NATIONS, 1977. Sekwari:ɵre Chief Leo Henry is seen here standing third from the right, with the Haudenosaunee delegation to the United Nations in Geneva, Switzerland. The Haudenosaunee delegation, along with many indigenous people from across North America, presented papers and points of view to the United Nations about oppression suffered by their peoples. (Courtesy Susan Patterson.)

TUSCARORA LOCOMOTIVE. Once, trains passed through the nation parallel to Upper Mountain Road. In 1835, the construction of the Lockport and Niagara Falls Strap Railroad began, connecting Lockport to Niagara Falls. The straps referred to iron straps that were laid on the wooden rails. The 24-mile run stopped in Pekin, crossed through Tuscarora, and stopped again at the Junction House west of Tuscarora. The Junction House was demolished for the construction of the Lewiston Reservoir. The train was somewhat of a local amusement, and Tuscaroras were often seen racing the train on horseback. The map (seen in the image below) depicts the railroad route to Niagara Falls. (Above, courtesy Susan Patterson; below, courtesy Niagara Falls Public Library.)

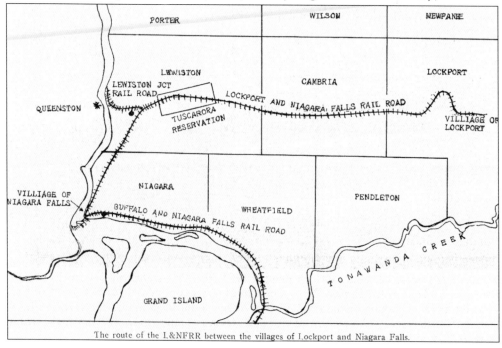

The route of the L&NFRR between the villages of Lockport and Niagara Falls.

THE INDIAN'S SACRIFICE POSTCARD. "The Maid of the Mist" was an inaccurate story of human sacrifice. Haudenosaunee history of Niagara Falls was romanticized by non–Native Americans, who were looking for the dreamy, sensational story. The oral tradition of the Haudenosaunee tells of spirits living beneath the Niagara Falls, called Thunder Beings, saving a young woman from taking her own life. (Courtesy Niagara Falls Public Library.)

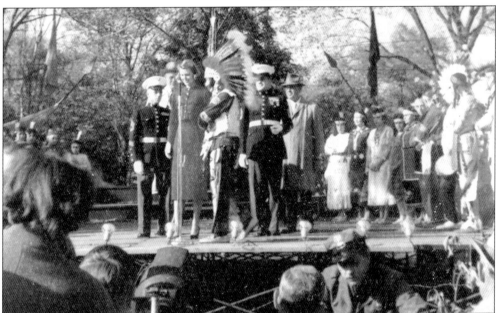

MAID OF THE MIST CELEBRATION. During the 1950s, the City of Niagara Falls held a Maid of the Mist Celebration and Parade. Women competed to be crowned the Maid of the Mist. Miss America 1956 was honorarily adopted into the Bear Clan by Clanmother Cinderella Printup during the celebration. She appears at the celebration as many Tuscaroras look on from the stage. (Courtesy Suzanne Goater.)

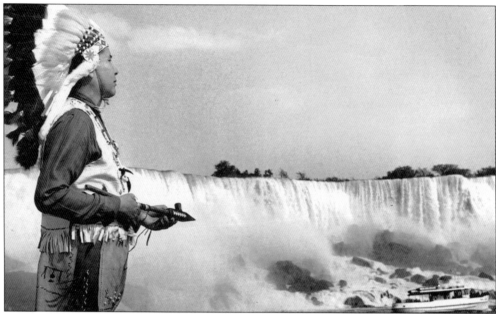

TUSCARORA AND THE NIAGARA FALLS. Niagara Falls's proximity to the Tuscarora Nation often influenced them during the 19th and 20th centuries. People often imagine a Native American when they think of Niagara Falls. Together they represent an inseparable fixture on the landscape. Over the years, Tuscarora people would take advantage of this notion by donning western-style clothing, typical of the Hollywood stereotype, while making advancements towards their own social and economic causes. (Courtesy Niagara Falls Public Library.)

TUSCARORA WOMEN SELLING BEADWORK. During the War of 1812, Tuscarora men served and protected U.S. general Peter Porter. As a reward, the Porter family gave the Tuscarora women the right to sell their beadwork in perpetuity on their land along the Niagara rapids. In 1885, the Porter land became known as Prospect Park, and Tuscaroras continue to sell beadwork to the international visitors. (Courtesy Niagara Falls Public Library.)

THE TUSCARORA BEADWORK TRADE. Prior to 1815, Native Americans and whites made many trips to the mighty Niagara Falls. Western New York was still considered a frontier, and tourism was relatively unknown. Although native Seneca and Mohawk people traveled to Niagara Falls to sell their work, it was the nearby Tuscaroras who dominated the trade. This 1879 depiction is from a *Frank Leslie's Illustrated Newspaper* article titled "New York–Summer Life at Niagara Falls." The picture frame (below) was made in the shape of a common symbol, the horseshoe, and shows the words *Niagara Falls.* They were both popular for the tourist trade in the 1950s. (Right, courtesy Niagara Falls Public Library; below, courtesy Rosemary Hill.)

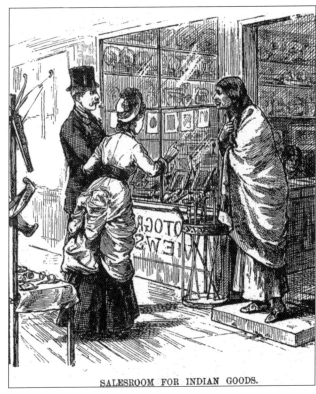

SALESROOM FOR INDIAN GOODS.

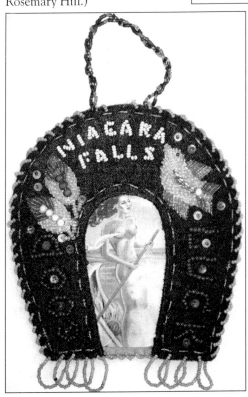

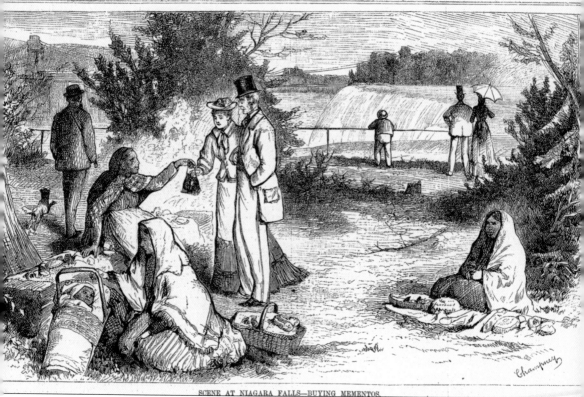

SCENE AT NIAGARA FALLS—BUYING MEMENTOS.

THE ART OF TUSCARORA BEADWORK, 1877. Tuscarora women would set up near the Niagara Falls and offer moccasins, dolls, beaded picture frames, purses, wall hangings, and other items. Ever since the 1820s, Tuscarora women have been selling their beadwork to the tourists at Niagara Falls. It is a very distinctive kind of beadwork, influence by both Native American symbolism and Victorian Era elegance, known as embossed or raised beadwork. This drawing of Victorian travelers buying a souvenir from Tuscarora women highlights the relationship between the Niagara Falls and Tuscarora. Children at the Tuscarora Indian School organized a company called the Tuscarora School Beadworkers under the principal Stanley Johnson. When Albany instructed elementary schools to teach students about the U.S. Constitution, the company drafted the Constitution of the Tuscarora School Beadworkers, consisting of legislative executive and judicial articles. (Courtesy Niagara Falls Public Library.)

FOUR NATION CELEBRATION RUNNERS, 1934. A 600-mile relay race from Fort Niagara to Washington, D.C., was held to invite Pres. Franklin Roosevelt to the Four Nation Celebration. The Tuscarora runners (seen in the image above) are, from left to right, unidentified, John Hill, Irving Bissell, Edison Mt. Pleasant, Sam Jacobs, William Greene, Osborne Chew, Allan Jack, Clifford Printup, John Pembleton, Tracy Johnson, Murray Printup, Noah Henry, and unidentified. The Celebration at the Fort Niagara was for England, Canada, France, and the United States. The runners (seen in the image below), preparing to leave with their Greyhound bus, self imposed Native American names beforehand like, Longtime Sleep, Flying Eagle, Knock Off Three, Bird Lying Down, and Sitting Beaver. (Courtesy Tuscarora Environment Office and Richard Hill Sr.)

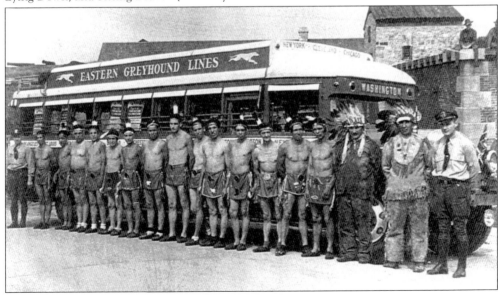

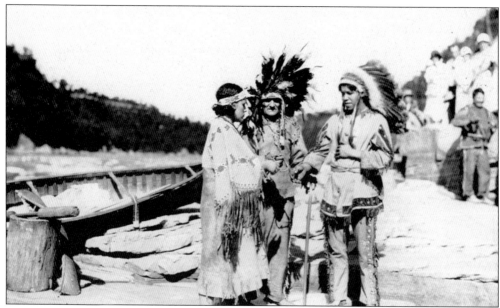

TUSCARORA WEDDING CEREMONY, 1934. During the Four Nation Celebration, the Tuscarora agreed to conduct a wedding ceremony along the Niagara River. In the image above are, from left to right, bride Vivian Rickard; Chief George Rickard, grandfather of the bride; and groom Clifford Printup. It was common for Tuscaroras to dress with western headdresses, reflecting the times, and buckskin dresses. The photograph below is Chester Rickard, son of George Rickard, posing next to the canoe from the above picture. (Courtesy Niagara Falls Public Library.)

UNCLE AND NEPHEW ON MOUNT HOPE ROAD. The reservation is located only four miles from Niagara Falls, a short walk in the old days. Tuscaroras routinely traveled into the city for work and play. Most people divided the town into two separate regions, the North End and the South End. In this photograph are Howard "Hoo Doo" Mt. Pleasant (left) and his uncle Clinton "Inch" Mt. Pleasant. (Courtesy Tuscarora Environment Office.)

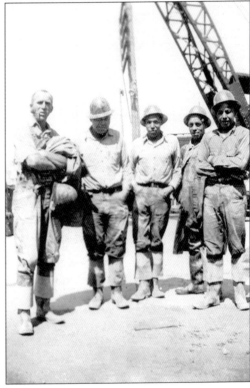

TUSCARORA TUNNEL WORKERS. During the early 20th century, industry was flourishing in Niagara Falls. Many Tuscarora old-timers still remember walking to the city from the reservation and getting hired along the way. This photograph, from the late 1950s, shows Tuscaroras working on the construction of the conduits for the Niagara Power Project. In this image are, from left to right, Christopher Young, William Jacobs, Michael Jacobs, unidentified, and Emmett Printup Sr. (Courtesy Suzanne Goater.)

TUSCARORA IRONWORKERS. Ironworking is a popular building trade at Tuscarora. Many Tuscaroras were employed in the steel-beam construction of popular buildings, including the Empire State Building in New York City. Tuscarora ironworkers, like their Mohawk brothers on the Canadian border, often traveled to work in Canada. In 1928, a federal judge ruled in a deportation case that the Haudenosaunee had retained their rights as aboriginals to freely travel for work and trade across the international border. Ironworking unions in Niagara Falls continue to employ many Tuscaroras who travel long distances for work. Some scholars have suggested that ironworking has assumed the male role of hunting and gathering in Native American societies. By 1890, there were 78 laborers at Tuscarora and only 47 farmers reported in the Census of the Six Nations. (Courtesy Tuscarora Environment Office.)

TUSCARORA CHILDREN AND WAMPUM. An imaginary line in the middle of the Niagara River represents an international boundary according to the United States and Canada. Tuscarora citizens are permitted to cross freely for trade and travel according to international treaties with the Six Nations of the Haudenosaunee. Many treaties are represented by belts made of wampum beads, from the shells of Quahog mussels. Brothers William (left) and Clark Rickard are holding the Hudson's Bay Company Belt at an Indian Defense League Celebration. (Courtesy Norton Rickard and family.)

SUPPORT FOR INTERNATIONAL BORDER CROSSING. Seen here are, from left to right, Chaney Isaac, Roby Davey, Clinton Rickard, and George Nash. The Indian Defense League of America (IDLA) was started in 1926 by several Tuscarora dignitaries, including Clinton Rickard. A strong supporter was George Nash, a Cayuga who lived at Tuscarora for more than 16 years. Rickard once claimed Nash was the only person left at Tuscarora who could still build a bark house. (Courtesy Norton Rickard and family.)

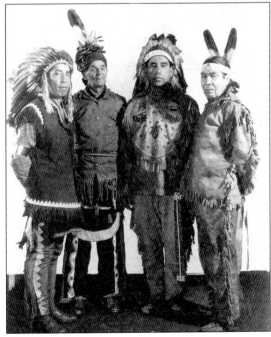

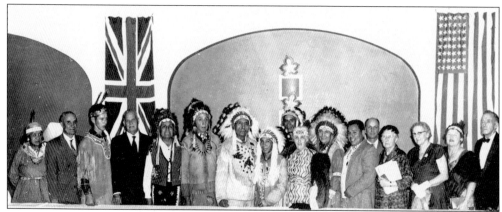

MEETING OF THE INDIAN DEFENSE LEAGUE, NOVEMBER 8, 1958. The meeting was held at the Brock Hotel in Niagara Falls, Ontario. Pictured here are, from left to right, Mrs. Corbett Sundown, unidentified, Donald Richardson, Herbert C. Holdridge, Corbett Sundown, Jack General, Clinton Rickard, Morris Chaplin, William Rickard, Mrs. A. J. Holman, David Hill, Wallace "Mad Bear" Anderson, William Smith, Mrs. L. G. Stillman, Mrs. Roger Millar, Mrs. Warner, and Roger Millar. (Courtesy Norton Rickard and family.)

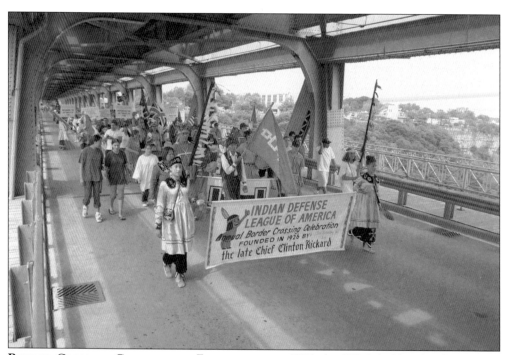

BORDER CROSSING CELEBRATION. Every year since 1927, the IDLA holds a border-crossing demonstration across the international border. The event includes a parade across the Whirlpool Bridge in Niagara Falls and a field day of activities, including Native American speakers. Descendents of Clinton Rickard continue to participate in the tradition today, every third Saturday in July. (Courtesy Niagara Falls Public Library.)

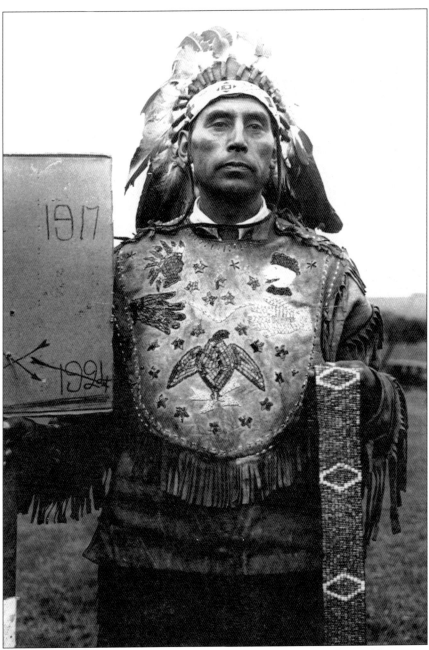

CLINTON RICKARD, BEAVER CLAN. Rickard was born in 1882, the third son of George and Lucy Rickard. He attended school on the reservation until he was 16 years old, when he completed the third reader. Despite his lack of formal education, he became a moving orator who could decipher the most complex legislation affecting Tuscarora. Rickard enlisted in the U.S. Army at Fort Niagara in 1901. During the Spanish-American War he traveled to the Philippine Islands, where he contracted malaria. He was discharged from the army in 1904 after being stationed at Fort Des Moines, Iowa. He once said there was no harm in volunteering, but Native Americans should not be forced into the military draft. He returned to Tuscarora in 1904 and began to work again on the family farm. (Courtesy Norton Rickard and family.)

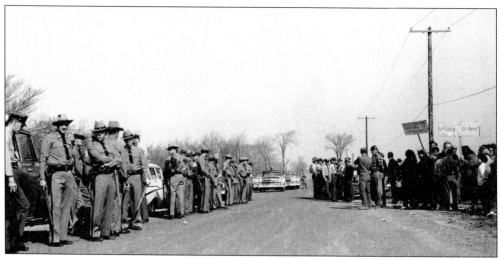

PROTESTING THE STATE POWER AUTHORITY RESERVOIR, 1958. The State Power Authority commenced expropriation proceedings under New York State law. In April 15, 1958, the State Power Authority made a formal request for 1,383 acres of Tuscarora land by filing a map with the county. Surveyors were sent out the next day. The surveyors were refused entry, and soon protests began. At one point, about 150 Tuscarora Nation residents faced off against 62 State troopers, county sheriffs, and project officials. The police were armed with riot gear and submachine guns. (Courtesy New York Power Authority Archives.)

LOCAL NEWSPAPER CARTOON, 1958. Robert Moses painted a bleak picture of Tuscarora in the media, hoping to shame the Tuscaroras into submission. He also made it appear that he was more than fair in his offers and that the Tuscaroras were standing in the way of progress. He attributed Tuscarora objections to a "small number of recalcitrants." The use of cartoons by the local newspaper created an image of Tuscaroras as a hindrance to the progress of the Niagara Region. (Courtesy Suzanne Goater.)

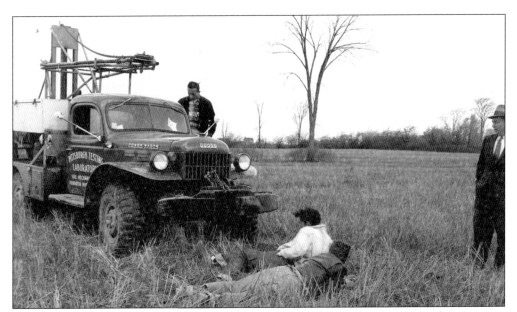

PASSIVE RESISTANCE TO CONSTRUCTION, 1958. Moses blamed the Tuscaroras for expensive delays and attempted to make it appear that the Tuscarora opposition would cost the entire region millions in wasted opportunities. Moses implied that if Tuscarora land was not taken, then the land of nearby white families would be taken instead, driving a wedge between the Tuscarora and their neighbors. It was common practice for Tuscaroras to passively resist the project's encroachment by lying in front of trucks and equipment. (Courtesy New York Power Authority Archives.)

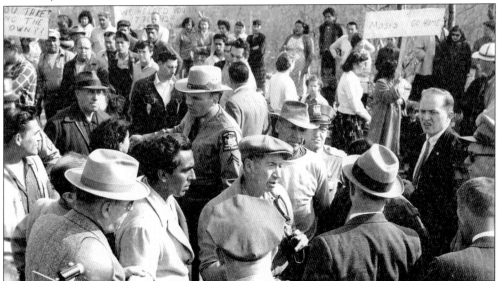

ON THE FRONT LINES AT TUSCARORA. Protests formed as New York State Power Authority work crews entered the Tuscarora territory. Confrontations developed with work crews. State police were called in to protect the workers. Arguments, pushing, and shoving resulted. Several Tuscaroras were arrested. On April 17, 1958, when a large gathering of protestors faced off against the state police, three men were arrested: William Rickard, John Hewitt, and Wally Anderson. The charges were later dismissed. (Courtesy New York Power Authority Archives.)

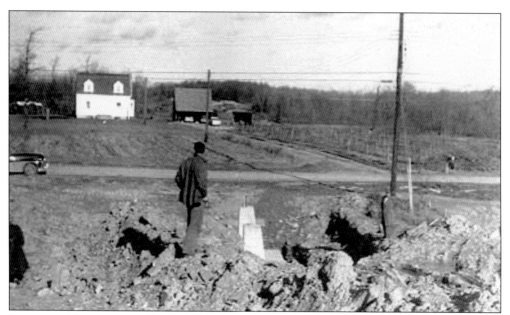

INTRUSIVE TRANSMISSION LINES. Nine percent of Tuscarora lands were taken for the New York State Power Authority Project in 1956. Around 495 acres of land were taken by eminent domain and were flooded by the reservoir and about 55 acres of land for the transmission lines. Dorothy Crouse's home is in the background as the foundation for the transmission lines are settled in. (Courtesy Tuscarora Environment Office.)

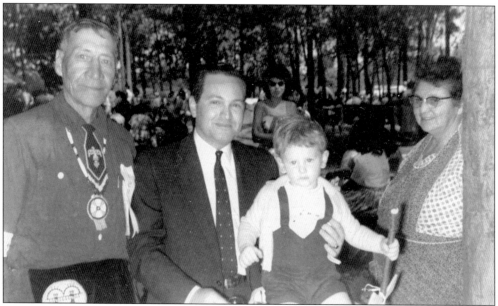

ARTHUR LAZARUS AT THE TUSCARORA PICNIC. The Tuscarora Nation hired Arthur Lazarus and Richard Schifter of Strasser, Spiegelberg, Fried, and Frank from Washington, D.C., to represent the Tuscarora Nation against the New York State Power Authority. Lazarus eventually took the case all the way to the U.S. Supreme Court in 1960. Seen in this image are, from left to right, Chief Harry Patterson, Attorney Arthur Lazarus, his son, and Barbara Patterson. (Courtesy Suzanne Goater.)

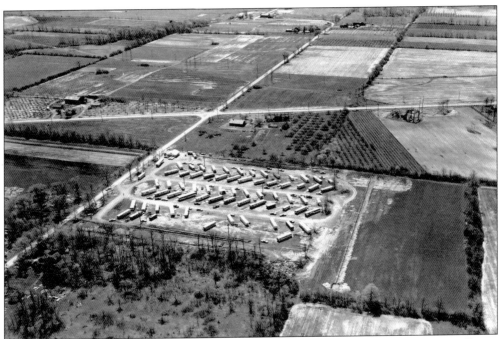

TUSCARORA TRAILER PARKS. Some Tuscaroras opened trailer parks on the reservation, offering cheap housing for the influx of Niagara Power Project construction workers. After the Niagara Power Project was completed, many non–Native Americans stayed on the nation territory and became a source of strife within the community. The Tuscarora Nation had to launch legal proceedings to evict the non–Native Americans. On August 31, 1970, Niagara County Judge Hogan ruled that non–Native Americans residing on the Tuscarora Indian reservation must leave, enforcing an eviction notice from the Council of Chiefs. While the Tuscarora Nation won their jurisdictional issue, ongoing strife was experienced with the trailer court operators and their families. The photograph above, of Deerhead Trailer Court on Walmore Road, was taken by the New York Power Authority. Below, a sign hangs in the same trailer court following the eviction by the Council of Chiefs. (Above, courtesy New York Power Authority Archives; below, courtesy Tuscarora Environment Office.)

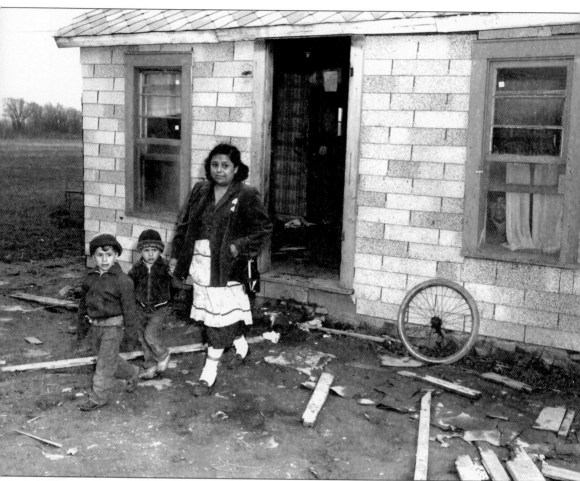

GREENE FAMILY FORCED TO LEAVE THEIR HOME, 1960. Robert Moses, State Power Authority, published materials to refute the Tuscarora claims for their own land and made it seem like the Tuscaroras were foolish for not accepting his generous offers to pay for land, rebuild homes, build new roads, and a new community center. However, in a private memo Moses wrote, "No use giving the redskins something they won't take care of." After a lengthy legal battle, the Tuscarora Nation lost their case after the U.S. Supreme Court decided the lands they occupied were not considered a reservation. According to their definition. The decision is still seen by Tuscaroras as a violation of the Treaty of Canandaiqua, made in 1794 between the Six Nations and the United States. In this photograph, Emma Greene and her two boys, Orville and Arthur, are forced to leave their home for the last time. (Courtesy New York State Power Authority Archives.)

RELOCATING TUSCARORA HOMES. The construction of the Lewiston Reservoir caused 29 Tuscarora households to be relocated. Demolition, fire, or disassembly removed 13 dwellings. Nine homesteads were relocated within the reservation boundary. Some of the families affected by the relocations are Burton and Josephine Farnham, Earl and Emma Greene, Harry and Barbara Patterson, William and Bea Mt. Pleasant, Paul and Elise Wagner, Franklin and Isabelle Patterson, Charles and Emily Johnson, David and Mary Roy, Leander and Judith Patterson, and Kenneth and Florence Patterson. In the image below, Elmer Mt. Pleasant's home is burning to the foundation at the corner of Moyer Road and Garlow Road. In the image above, Charlie Johnson's home is moved to its present location on Indian Hill. (Above, courtesy New York Power Authority Archives; below, courtesy Neil Patterson Jr.)

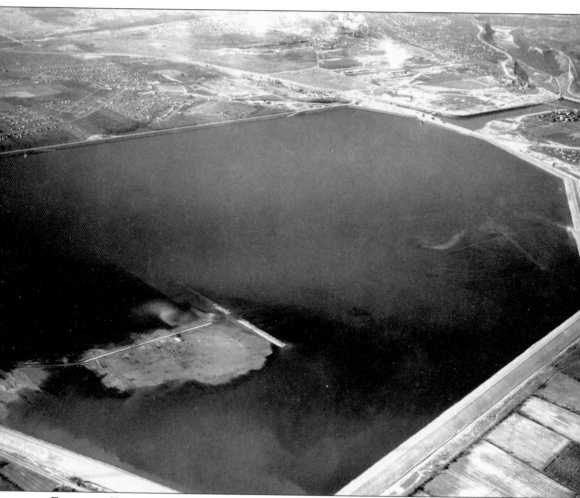

FLOODING TUSCARORA LAND. In 1960, the U.S. Supreme Court ruled in a split decision that the section of Tuscarora land conveyed to the Tuscarora Nation "for Ever" by Gen. Henry Dearborne was subject to condemnation for the construction of the Niagara Power Project. In the dissenting opinion, Justice Hugo Black wrote, "It may be hard for us to understand why these Indians cling so tenaciously to their lands and traditional tribal way of life. The record does not leave the impression that the lands of their reservation are the most fertile, the landscape the most beautiful or their homes the most splendid specimens of architecture. But this is their home—their ancestral home. There, they, their children, and their forebears were born. They, too, have their memories and their loves. Some things are worth more than money and the costs of a new enterprise. . . . I regret that this Court is to be the governmental agency that breaks faith with this dependent people. Great Nations, like Great Men, Should Keep Their Word." This photograph shows the Patterson farm foundation and Moyer Road as the reservoir is flooded for the first time. (Courtesy New York Power Authority Archives.)

Eight

COMMUNITY CELEBRATION

MAPLE SYRUP TIME. The shallow soil of the Niagara Escarpment is home to many sugar maple trees. Norton Rickard continues to gather syrup from the same trees that his grandfather collected from. In this photograph, Rickard keeps a constant vigil on the boiling sap at the sugar bush, where he still uses a traditional wood fire and iron kettle. (Courtesy Neil Patterson Jr.)

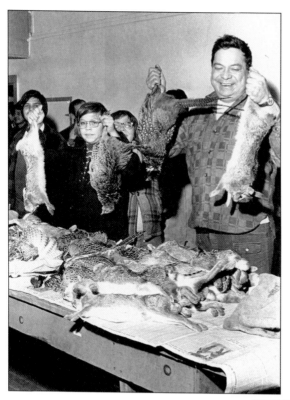

THE COUNT AT NEW YEAR'S. Three days before the New Year's Feast, "old-men" and "young-men" compete in a hunting contest. Deer, rabbits, and turkey are assigned points based on their abundance. Old-men are men with children, while young-men have yet to father a child. Shortly after sundown, the people gather at the Old Gym to watch captains assigned to their respective teams tally the score in the Tuscarora language. Losers of the contest are required to clean all of the game, which is used for the feast. In the left photograph, the respective captains, young-man Ronald Henry (left) and old-man Eugene Greene, display their bounty. Below, Percy Abrams (left) and an unidentified person are skinning a deer at the Old Gym. (Left, courtesy Eugene and Elva Greene; below, courtesy Joanne Weinholtz.)

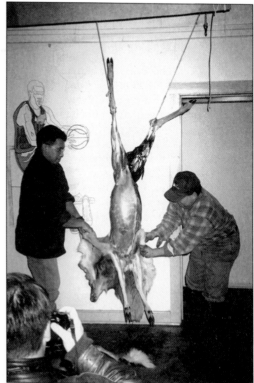

PREPARING FOR THE FEAST. Before the Old Gym was constructed in the 1920s, the preparations for the New Year's Feast were conducted in the basement of the Tuscarora Baptist Church. In this photograph, from left to right, Louise Henry, Harriett ?, and Amelia Williams prepare food for the New Year Feast. Annually on New Year's Day, Tuscarora comes together for a communal feast of traditional foods like venison, corn bread, vegetables, rabbit pie, and wild game. It is open to the public and starts at midday, after nyú:ya is complete. Nyú:ya is a very long tradition of going from home to home at Tuscarora and wishing family and friends a happy new year. In return, the well wishers receive some kind of baked good like donuts, cookies, small cakes, slices of pie, and if one is lucky, a cookie representing the home's clan. At special homes, a visitor may yell "Nyú:ya awire:tih" and receive a more delicious treat. (Courtesy Tuscarora Environment Office.)

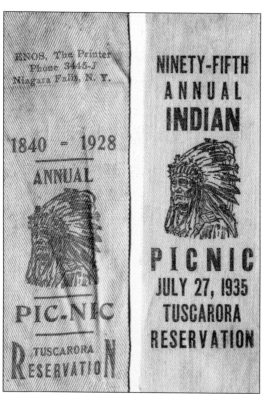

TUSCARORA NATION PICNIC. The Tuscarora Nation Picnic originally started as a church Sunday school event in 1845. It was first held in a wooded grove on the south end of Walmore Road. It later moved to its present day location, north of the Tuscarora Indian School. Ribbons were often handed out to commemorate the event, but the dates were always said to be incorrect. (Courtesy Tuscarora Temperance Society.)

HORSESHOES IN THE PICNIC GROVE. Seen here is a familiar scene of horseshoes at the Tuscarora Nation Picnic and Field Days. During the first years at the current Picnic Grove, sports and agriculture were the main events for the Tuscarora Nation Picnic. The drinks and foods, however, were always the most popular. (Courtesy Chief Kenneth Patterson and family.)

CORN-POUNDING DEMONSTRATION. Turtle clanmother Harriet Pembleton (left) and Beaver chief Noah Henry demonstrate pounding corn at the Tuscarora Nation Picnic. The two most popular foods at the Tuscarora Nation Picnic are corn soup and corn bread; both are made with traditional Tuscarora white flour corn. (Courtesy Tuscarora Indian School.)

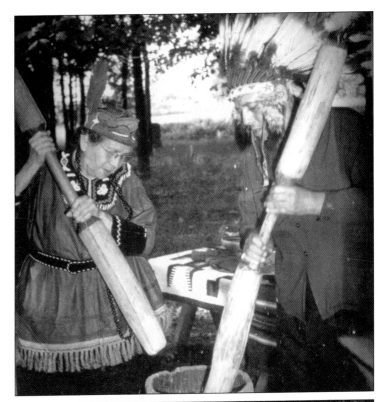

LUNCHING AT THE NATION PICNIC. The gathering of family and friends at the Tuscarora Nation Picnic is the highlight each year. Tuscaroras who have moved away come back at least once a year, to eat and enjoy each other's company at the Tuscarora Nation Picnic. Sitting at the picnic tables are, from left to right, (first row) Marjorie Printup and Helen Johnson; (second row) Chief Elton Greene, Simpson Rickard, and Harriet Pembleton; (third row) Edith Jonathan. (Courtesy Richard Hill Sr.)

126TH TUSCARORA NATION PICNIC, 1971. Seen here are, from left to right, Chief Arnold Hewitt, Ann Rickard (Tuscarora Princess), Chief Leo Henry, Chief Elton Greene, and Lowell Osborne Jr. There is a long standing tradition of selecting an Indian princess at the annual picnic. In 2006, Ciera Fauzey is the reigning Tuscarora Princess. (Courtesy Buffalo State College, Courier Express Archives.)

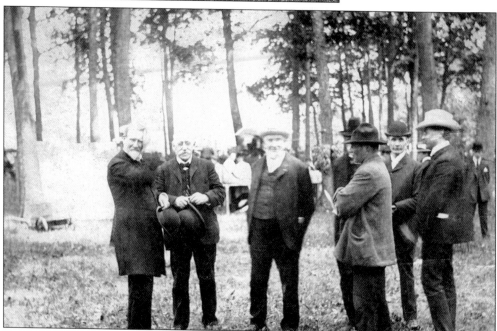

TUSCARORA CENTENNIAL PICNIC. Under the canopy of the Picnic Grove trees, Tuscaroras and local dignitaries gathered to commemorate the 100th anniversary of Tuscarora. Speeches, ceremonies, and pageantry highlighted the celebration, as people from all over visited Tuscarora Nation. (Courtesy Chief Kenneth Patterson and family.)

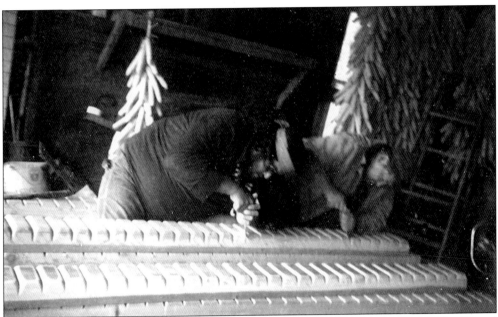

UNCLE AND NEPHEW WOODWORKING, 1976. Franklin "Bigman" Patterson Jr. and Chief David "Manny" Patterson are constructing the corn statue for the New York State Fair Indian Village, which still stands today. Chief Patterson's father, Harry, was one of the many Tuscaroras who formed the 6-Nations Agricultural Society. This society was responsible for acquiring land at the New York State Fair for the sole use of the Haudenosaunee, in the 1930s. (Courtesy Susan Patterson.)

MYNA SMITH AT THE TUSCARORA BOOTH. Many Tuscarora families make a yearly pilgrimage to the New York State Fair Indian Village. It continues to be a serious source of income for some families, as they display their art and beadwork for the tourists to buy. Each reservation tends to a bark stand at the New York State Fair. Seen here is Myna Smith displaying her beadwork at the Tuscarora booth. (Courtesy Chief Kenneth Patterson.)

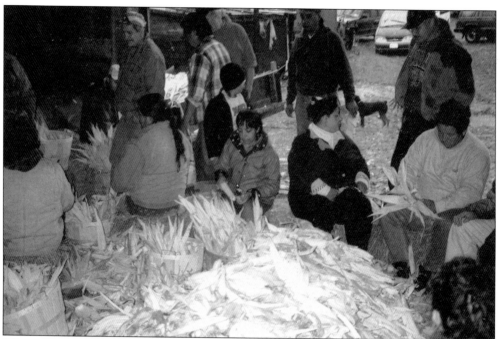

WORKING THE HUSKING BEE. The husking bee is a community event for people to help in the harvest of corn. A large husking bee takes place every year on the Norton Rickard farm, where people from all over gather to help husk and braid corn in exchange for a warm meal. In the photograph people surround a large pile of unhusked corn waiting to be braided. (Courtesy Neil Patterson Jr.)

LACROSSE TEAM IN WASHINGTON, D.C. The Tuscarora Athletic Club was invited to play high school lacrosse teams in the Baltimore-Washington, D.C., area in 1963. The Tuscarora athletes were hosted by local families for the four-day tournament and they won the games easily. Here the teams are standing together on the steps of their local high school. (Courtesy Fillmore and Dorene Rickard.)

TUSCARORA LACROSSE PLAYERS. The Tuscarora Lacrosse Club played Streetsville, Ontario, at the 109th Tuscarora Nation Picnic and Field Days, in the lacrosse box on Walmore Road. The athletes are, from left to right, (first row) coach Noah Henry, John Hill, Connie Pembleton, Ray Hill, Sam Crogan, Edward Crogan, William Farnham, and Steven Crogan; (second row) Albert Gansworth, Harvey General, Benson Cusick, Bud Smith, Albert Bomberry, Quinten Printup, Walter Patterson, Francis Henry, and Bruce Reynolds. (Courtesy Tuscarora Environment Office.)

TUSCARORA CHILDREN'S CONTEST. Children sitting on the steps of the Picnic Grove stage for the annual children's contest at the Tuscarora Nation Picnic and Field Days. Over the last 30 years, traditional Haudenosaunee dress of *gustowahs*, traditional male headdresses made from split feathers attached to bent wooden splints, have become more prevalent. (Courtesy Tuscarora Language Committee.)

WORKING AT THE NEW YEAR'S FEAST. It is uncertain when members of the Tuscarora Temperance Society took charge of the New Year's Feast, but they still help organize the event today. In the above photograph, from left to right, Amelia Williams, Edna Johnson, Beulah Mt. Pleasant, and Amy Rickard prepare food at the Baptist Church on Mount Hope Road. In the photograph below, from left to right, Arthur Davis, Allan Davis, Delma Mt. Pleasant, and Helen Printup shuck corn for the feast. Tuscarora white flour corn is stripped from the cob, while game is being cleaned following the count. (Courtesy Tuscarora Environment Office.)

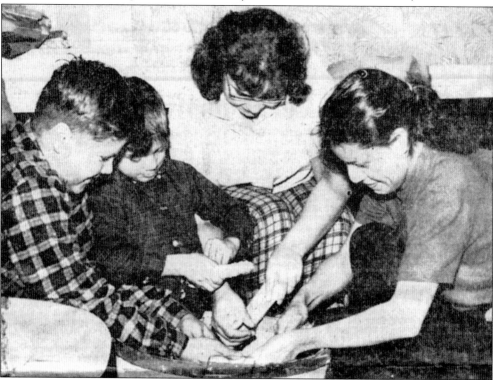

BIBLIOGRAPHY

From Fort Niagara, 1800. New York: Buffalo Historical Society Publication, 1903.

Graymont, Barbara, ed. *Fighting Tuscarora: The Autobiography of Chief Clinton Rickard.* New York: Syracuse University Press, 1973.

Hauptman, Laurence M. *The Iroquois in the Civil War: From Battlefield to Reservation.* New York: Syracuse University Press, 1993.

Hauptman, Laurence M. and George Hamell. *George Catlin: The Iroquois Origins of His Indian Portrait Gallery.* Quarterly Journal of the New York State Historical Association, Spring 2003.

Hill, Richard. *The History of Chiefs: Titles of the Tuscarora Nation.* Haudenosaunee Resource Center, 2005.

Hodge, Frederick Webb, ed. *Handbook of American Indians North of Mexico.* Michigan: Scholarly Presentation, 1968.

Johnson, Elias. *Legends, Traditions and Laws, of the Iroquois, or Six Nations, and History of the Tuscarora Indians.* New York: AMS Press, 1978.

Landy, David. "Tuscarora Among the Iroquois." *Handbook of North American Indians.* Vol. 15, Northeast. Bruce G. Trigger, ed. Washington, D.C.: Smithsonian Institution, 1978.

Robertson, Josephine. *Tuscarora Teen-agers.* Classmate Magazine, April 1951.

Sturtevant, William C. "David and Dennis Cusick, Early Iroquois Realist Artists." *American Indian Art Magazine,* Spring 2006.

The Six Nations of New York: The 1892 United States Extra Census Bulletin. Ithaca: Cornell University Press, 1995.

Williams, Ted. *The Reservation.* New York: Syracuse University Press, 1976.

Across America, People are Discovering Something Wonderful. Their Heritage.

Arcadia Publishing is the leading local history publisher in the United States. With more than 3,000 titles in print and hundreds of new titles released every year, Arcadia has extensive specialized experience chronicling the history of communities and celebrating America's hidden stories, bringing to life the people, places, and events from the past. To discover the history of other communities across the nation, please visit:

www.arcadiapublishing.com

Customized search tools allow you to find regional history books about the town where you grew up, the cities where your friends and family live, the town where your parents met, or even that retirement spot you've been dreaming about.